MANUAL OF
Darkroom Procedures
AND
Techniques

MANUAL OF
Darkroom Procedures
AND
Techniques

PAUL JONAS

AMPHOTO
American Photographic Book Publishing Co., Inc.
New York

Second Printing January 1973

Copyright © 1971 by American Photographic Book
Publishing Co., Inc.

Manufactured in the United States of America.

Library of Congress Catalog Card No. 74-164637.

ISBN 0-8174-0541-0

Contents

PART I: Negative Processing 6

1 The Procedure in Principle 7

2 The Darkroom:Equipment for Negatives 19

3 Negative Processing Materials 36

PART II: Positive Processing 52

4 The Procedure in Principle 53

5 Equipment for Processing Prints 58

6 Print Materials 79

PICTURE PORTFOLIO 91

PART III: Color Processing 124

7 The Procedure in Principle 125

8 Color Equipment 133

9 Color Processing Materials 145

APPENDIX I 151

APPENDIX II 155

INDEX 159

PART I
NEGATIVE PROCESSING

The Procedure in Principle

The Latent Image

When the shutter is released, light enters the camera and certain changes are introduced in the molecular structure of the tiny silver bromide crystals of the film emulsion. These light sensitive crystals are distributed evenly in the emulsion, in any section of which we can find equal quantities of large, medium, and small crystals. The larger the crystal, the more sensitive it is to light. Therefore, a fast film contains more large crystals than a slow one. I will speak about this later.

For the moment I will not take the inherent speed of the film into account, for I wish to explain that the stronger the light, the more crystals are changed in their molecular structure and the amount of changed crystals is proportionate to the strength of the light. In this way, the density of these changes follows exactly the density of the image that is projected by the lens onto the film. Since the changes are invisible until the film is developed, the entire complex of the changed silver bromide crystals is called a *latent image.*

For those who are more interested in the chemistry and physics of photography, I would like to explain further how this latent image comes into being. In an unexposed film emulsion, the elements of the silver bromide crystals are in complete balance. They

are strongly attracted to each other, because the silver-ion presents positive electricity, while the bromide-ion presents negative electricity. When the film is exposed, light penetrates the emulsion. Light penetrates in the form of photons, and each photon pushes out an electron from its orbit around the nucleus of the bromide component of the crystal.

In such a way electrons gain energy and fly out from the attractive force of the bromide nucleus. They are not free too long, however, because they are soon captured by the so-called "electron traps." These traps come into being during the manufacturing process of the silver bromide emulsion, in the form of irregularities in the crystal structure of the emulsion or foreign matter in this structure (mostly silver sulfide and silver molecules).

Since the electrons captured in these traps have a negative charge, the electron trap has a negative charge, too. These negative electron traps then attract the free silver-ions of the crystal, which have a positive charge, and become neutral again. This process continues until the photons produce free electrons. The more photons that penetrate the emulsion, or the stronger the light effect, the more electrons will settle in the electron traps, and the more metallic silver will be developed, thus producing the latent image.

Developing the Latent Image

We have to transform this latent image into a visible (and printable) one. For this purpose we use a solution called *developer*. The developer works first on those crystals that have been exposed to light, transforming them into metallic silver. The more silver bromide crystals in a certain area that have been changed by exposure, the more metallic silver is developed by the developer. The density of the silver image follows approximately the density of the latent image, unless some mishandling causes excessive de-

viation from the latent image. This may be too soft or too contrasty development of density differences, or, in extreme cases, too low or too high overall densities (lack of shadow details, unprintable highlights, or even fog). Mishandling can cause excessive graininess, reduced acutance, and uneven development—just to mention a few other dangers.

When I said that the developed silver image follows the density of the latent image only approximately, I meant that a negative should record the contrast differences of nature at a lower rate than they are in reality because of the limited contrast rendering ability of photographic papers, which is 1:30. The contrast rendering ability of films is about 1:1000, but we can't take full advantage of this range. The inherent contrast rendering ability of the film, the type of developer, and the developing methods determine the gradation of a negative.

Developer can penetrate the crystals only through those spots where metallic silver has been accumulated and, therefore, are electrically neutral. At the other places on the surface of the crystals the developer is repulsed by the negative bromide-ions, which are adsorbed onto the surface of the silver bromide crystals, because the developer represents negative electricity also. After awhile the developer overcomes the resistance of the bromide and starts working on all surfaces of the crystals, producing fog. The bromide protects, for awhile, those silver bromide crystals that received no illumination. If the action of the developer is interrupted in time, only those crystals that received illumination will be developed. Once the developer penetrates the crystal, it transforms all its mass into metallic silver. The action of the developer proceeds in the following manner: The developing agent passes over electrons to substitute the missing electron of the silver-ions. By gaining electrons, the silver-ions are transformed into silver molecules (metallic silver). When all the silver-ions of the crystal have been trans-

formed, the silver image reaches its final state. In addition to this, however, there are many other factors that influence the quality of the silver image, especially the size and distribution of the grains.

As I mentioned above, various sizes of silver bromide crystals are dispersed evenly in the gelatin of the emulsion. The larger the crystal, the more sensitive it is to light. This means that strong light affects all the crystals of the penetration area, whereas weak light affects only the larger ones. Thus, the latent image is proportionate to the light effect. Also, more latent nuclei are created on the same crystal if the light effect is strong. Because these are the gates for the penetration of the developer, it is obvious that the developer finishes its work sooner on those grains that allowed the developer to penetrate through more gates. It is apparent, also, that the more large crystals there are, the less light is needed to produce a certain density of silver image. On the other hand, if we interrupt the work of the developer in time, we can achieve relatively fine grain structure. The only problem with this procedure is that the pictures may turn out to be quite flat.

The original size of the silver bromide crystals is only one factor that may influence the graininess of the negative. Developing agents and other ingredients of the developer may influence graininess also. Developing agents do their job by passing over electrons. Certain agents are able to do this easily under special circumstances. Developing agents also vary in their ability to release electrons and differ in the number of electrons they can release. The ability of a developing agent to release electrons depends upon the pH index of the solution. The pH index represents the alkalinity or acidity level of a solution: pH 7 is neutral; pH numbers below 7 represent increasing acidity, while numbers above 7 indicate increasing degrees of alkalinity. The solution is completely acid at pH 1, completely alkaline at pH 14. Most of the developing agents can release their electrons only in alkaline solu-

tion, so the developer is more powerful if the solution is more alkaline. In passing over electrons, developing agents become oxidized. In time their power is exhausted. To protect the developing agent from oxidation, a preservative (usually sodium sulfite) is added to the solution. Most people believe that they prolong the developing time with used solution because the developing agents are "exhausted." This is not so. We have to extend the developing time after each use of the solution (if replenisher is not used) because of the increased accumulation of bromide in the solution, which comes from the emulsion when silver bromide is separated into metallic silver. I explained earlier how bromide-ions repulse the developer.

The alkalinity level of the solution is one of the most important factors governing the behavior of the developer. Most agents work very slowly, or not at all, at the low alkaline level of the sodium sulfite solution (pH 8). Therefore, other substances have to be added to the solution to increase its pH. Metol represents an exception, since its best working condition is at pH 8. The plain sodium sulfite solution is the best medium for metol. Increased pH increases graininess also; therefore, fine grain developers contain mild alkalies like borax, tribasic sodium phosphate, or small amounts of sodium carbonate.

When the entire bulk of the silver bromide crystal has been transformed into metallic silver, the formation does not follow the original outlines of the crystal. Branchy outgrowths are formed, and the developed grains are larger than the original crystals. Unfortunately, these larger grains move closer to each other during development, forming grain-clumps. The visible graininess of a picture is created by these grain-clumps. They become most conspicuous in those areas where the concentration of clumps reaches a certain degree. This occurs mostly in the grayish areas, in the middle tones, and in the out-of-focus areas, since these areas are

quite flat. This explains why low-contrast scenes and overexposed pictures can be grainy, while other frames on the same roll (the side- and backlit pictures, but in any case the more contrasty subjects) lack grain. For reduced graininess some developers contain a silver solvent substance, which hinders the agglomeration of grains and decreases the exaggerated growth of the single grains. Sodium sulfite is used most often for this purpose in high concentration (about 3 or 3½ ounces per quart). Higher concentration of silver solvent substances or strong silver solvent developing agents would produce extraordinary fine grain; however, they are no longer recommended, because they degrade critical sharpness and cause a loss of film speed.

Silver solvent developers are semiphysical in operation, which means that the dissolved silver goes into the solution and from there is plated again around and among the grains. In this way, the grain structure of the negative becomes more even. The only trouble is that this plating action occurs not only in the closest area of the grains but beyond it also, spreading out the contours so the fine details of the image merge and are lost.

Conclusion. Graininess of the negative depends upon the speed of the film, upon the exposure time (in relation to the film speed), upon the contrast of the subject or the illumination, and upon the ingredients and conditions (time, temperature, agitation) of the developer.

Manufacturers are continually striving to eliminate graininess as much as possible, and in the sixties significant progress was made, especially with high-speed films.

Choosing Film

It is advantageous to achieve and maintain an average negative contrast throughout your work. Since the features of various types and brands of films and developers are different in this rela-

tionship, developing technique must be tailored to achieve this goal. The film–developer combination and the developing technique influence two important features of the negative image: graininess and sharpness. An improper choice of film or film–developer combination and a careless or improper execution of the developing process can destroy our efforts to get pleasing results, or at least cause difficulties in the subsequent steps of enlarging or printing.

Now let us see what can destroy or at least degrade print quality. I described above how the grain is formed in the emulsion and how those branchy outgrowths and grain-clumps influence the grainy appearance of a negative. As a result of excessive graininess, the good definition of the lens is negated, and the originally sharp contours grow together and are lost. Improper development is a result of not only improper film–developer combinations but also overdevelopment. Improper development can cause problems besides excessive graininess in tonal rendition and sharpness. For instance, when film is exposed, some grains receive enough illumination to make them developable under normal conditions, while other, nearby grains receive a slight exposure also. Normal development will not develop these slightly exposed grains, but overdevelopment and forced development will develop them and destroy the original sharpness of the picture.

Overdevelopment also reduces sharpness in another way. Because overdeveloped negatives are high-contrast negatives, your choice of a proper paper grade becomes problematic, and as a final result visual sharpness is reduced because of the necessity to use a soft paper. The higher the contrast grade of the paper, the sharper the print appears because the contours show greater differentiation between black and white. Therefore, grain is more conspicuous on contrasty paper than on soft paper. What affects grain affects the fine details of the negative as well, since the grains are literally

the finest details of the negative image. The dimension of the grain is the same on soft paper, but it is less defined because of the decreased contrast. The sharpness of a picture enlarged on soft paper, therefore, appears less; on the other hand, normal or contrasty paper enhances sharpness.

Conclusion. In order to achieve greater sharpness, it is more advantageous to use a No. 3 or No. 4 paper rather than a No. 1 or No. 2, or the equivalent filters for variable contrast papers. Therefore, we should strive to obtain soft negatives, especially in the field of 35mm photography, in order to achieve visual sharpness in the final picture.

To make use of the aforementioned ground rules, it is important to know the types of films and developers to work with and to describe the inherent features of these types.

Films are generally represented by their speed index. There are four basic groupings of films today.

Slow films, under ASA 50. These are high resolution, extremely fine-grain films, with a tendency to increase contrasts. High resolution is possible because of the very thin emulsion layer, in which the probability of irradiation is decreased. (Irradiation is the spread of light within the turbid medium of the emulsion.) Because of the tendency of these films to be constrasty, soft working developers are preferred. These are either high-energy developers in a very low concentration or special formulas. In either case the developer has to be discarded after one use because of the low concentration of its ingredients. Regular developers (those that can be used several times) may also be used for these films if they are soft working. Because these films have a fine-grain structure, "ultra-fine-grain" developers are not needed.

Medium-speed films, ASA 50–200. Their gradation is good, and the higher-speed films of this group work in most situations, even indoors or under artificial light. The highly diluted develop-

ers recommended for slow films cannot be used for these films, but some developers with concentrated stock solutions can be diluted at a lower ratio to meet their needs. A good film–developer combination can be found in both diluted ("one-shot") and conventional types, since the gradation of films varies with make and since different developers provide different contrast.

High-speed films, over ASA 200. Most perform with tolerable to good graininess and good to excellent resolution and, because of recent improvements, can be used as all-purpose films. Their gradation is on the soft side, so there is less danger of building up extreme contrast even in very high contrast, available-light situations. Using these films, we can reproduce a scene in "available darkness." There is no reason to use an ultra-fine-grain developer of the older type, such as para- or orthophenilene-dyamine, because these developers decrease emulsion speed too much. Instead, we can use a regular fine-grain developer, which provides good graininess and satisfactory gradation.

Ultra-high-speed films, over ASA 400. In the sixties the greatest improvements in film were achieved in ultra-high-speed films. Their resolving power competes with that of the medium-speed films and their graininess, in the lower speed range, is so good that it approaches the highest standards set for sharpness. The ultra-high-speed films' official speed is ASA 400 and up, and as a result of their flat gradation curve, they do not tend to block up highlights when pushed moderately. Naturally, the graininess of films over ASA 400 is somewhat coarse, but progress in this respect is very fast, for not too long ago the graininess of the ASA 200 films was even coarser than that of today's ultra-high-speed films. The situation in resolving power is the same. The graininess of these fastest films will be over the limit of standards set for grainlessness if they are used under normal daylight conditions. When used in "available darkness," that is to say, where dark areas are

next to small, well-illuminated highlight areas and large gray
areas are lacking, ultra-high-speed films do very well, because
grain is most conspicuous in evenly lit gray areas. Provided, of
course, the proper developing techniques are used, eliminating
gray areas avoids the possibility of troubling graininess, too.

Once you are happy with a certain film–developer combina-
tion (together with its suggested or adjusted developing time),
you should not change unnecessarily to another one. This does not
mean that you should stick stubbornly to an old combination, but
it does mean that all the features of a certain film–developer com-
bination can be realized only when this combination has been used
several times under various shooting conditions.

Handling the Developer

The temperature of the developer, the rate of agitation, and
the time of development work together to achieve the needed
gradation and density of the film. A change in any one of these
factors alters the quality of the negative and affects the grain
structure of the film. These factors determine the quality of a neg-
ative as much as the choice of a film–developer combination, and
poor negatives may just as easily result from improper handling
of these factors as from an improper combination of film and de-
veloper. A higher temperature than recommended acts in the same
way as an increased developing time or an increased rate of agita-
tion. A lower temperature than recommended has the same effect
as reduced developing time and too infrequent agitation.

Another danger in connection with temperature is reticulation,
which occurs when the difference in temperature between the vari-
ous solutions and the water exceeds a certain limit. This causes a
contraction of the gelatin, which will look like dried out mud flats
when the film is dry. Therefore, we must take care that the tem-

perature difference does not exceed 5° F., or even less in certain cases, as when processing certain color films.

Reticulation may also occur when the film is transferred from a solution of high pH index to a solution of much lower one. Therefore, before transferring film from the alkaline developer to the acid hypo, we have to rinse it either in plain water, or in a mildly acid stop bath.

Effect of the Stop Bath

Service as a transition is only a side duty of the stop bath; its main object is to stop development immediately. The stop bath is acid, and developing agents are neutralized in an acid environment. Some photographers, however, take advantage of the continuing development of the shadow details when the film is transferred into plain water and left there for awhile, instead of using an acid stop bath.

The Function of the Hypo

In the hypo, all the remaining silver bromide content of the emulsion is dissolved, and only the developed metallic silver remains. This dissolving action of the hypo takes two steps: first, the silver bromide is transformed into a silver compound that is invisible and insoluble in water. Second, this silver compound is transformed into another silver salt, which goes into solution with water easily. The first step is complete when the emulsion clears. Making the silver salt soluble requires at least as much time as it takes for the emulsion to clear. If you do not take this additional time, after a few months, your negatives will be destroyed by the silver salt retained in the gelatin, regardless of how long you wash your film in running water.

On the other hand, it is inadvisable to leave film in hypo longer than necessary, because after awhile hypo may dissolve a small

amount of the developed silver—in this way fine shadow details may disappear. Fast acting fixers are particularly dangerous in this respect.

In general, a hardener is added to the hypo solution to protect the otherwise too soft emulsion from being scratched accidentally during washing, wiping, or drying. Moreover, the penetration of foreign materials—such as rust from the wash water—is greatly hindered when the emulsion is hardened.

A new kind of processing method has recently been developed: the so-called "monobath." This is a single-solution developer and fixer. The solution acts first as a developer, until a perfect negative has been developed, then as a delayed-action hypo. This type of solution is valuable not only for newsmen, but also for photographers who travel.

I will deal with the final steps of processing (washing and drying) in the third chapter.

2

The Darkroom: Equipment
for Negatives

For processing only negatives with contemporary methods and equipment, the simplest facilities are needed. First of all, you need a lighttight place. A mere changing bag will do.

Exposed films must be put into the developing tank in complete darkness. If the tank is lighttight, you do not need darkness during the subsequent steps of the processing. If you want to develop by inspection, the whole room must be dark.

The initial steps of the lighttight procedure without visual control are as follows: In a lighttight place, such as a changing bag, a closet (beware of dust), or a bathroom, place your film in the developing tank. Then go to any area of your home where running water is available. (Don't forget to obtain your wife's permission.) Place the loaded tank on a table or any other flat surface and go ahead. Some rules and precautions have to be maintained to achieve the wanted results. Moreover, there are devices available that make the processing more comfortable and safe. Therefore, I will describe the entire procedure in such a way that you may select the equipment that fits your personal need, taste, and purse.

Developing Tanks

There are three types of developing tanks available for both 35mm and roll film work. One is the daylight tank, which can be loaded without a darkroom. Just fasten the film to the leader of the reel; then place the cassette or roll in the receptacle. Close the entire unit and wind the film into the tank by a crank.

Self-loading tanks must be operated in a darkroom. Slip the film into the reel by rotating the halves of the reel back and forth. The construction assures that the film can only move forward while the film is dry. During processing, however, when we rotate the reel for agitation, the wet film may slip out of the groove, and insufficient developing and scratches will result. This is all the more likely to happen because the film becomes extremely slippery from the alkaline developer. Therefore, to reduce the possibility of the discs turning, we must bend back the outside end of the film. This increases friction between film and groove. This precaution is also advisable in regular reels, where the two discs of the reel do not rotate at all, even if there is a hook on the axis of the reel.

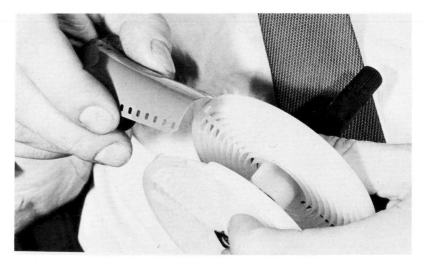

Loading tank: Film is bent and slipped into grooves...

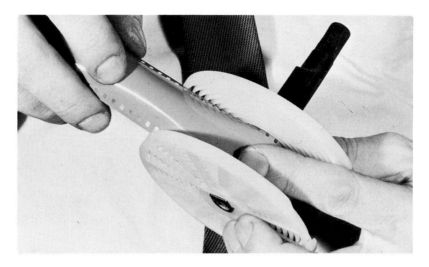

Film is hooked at the center of the reel...

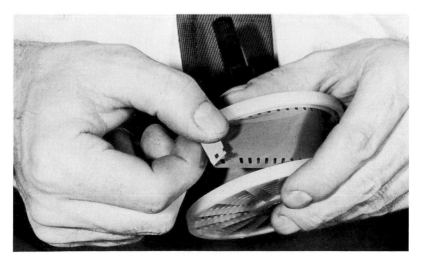

Film end is bent to avoid slipping out during agitation.

Sometimes it is difficult to slip a whole 36-exposure roll into a self-loading or regular plastic reel, especially when after long use plated silver develops on the grooves. In this case I recommend that the following method be used: We must load the film in the same way as we do in stainless steel reels; starting in the center and proceeding outward, with the film held bent between thumb and index finger. To ease this procedure, a special leader is available for bending the film properly without using our fingers. Another type of tank uses a plastic band, which is wound onto the wheel together with the film. The sprockets of the band assure the necessary clearing. Two rolls of film can be put back to back onto the band, and the whole outfit is safely fastened to the wheel by a clamp. Therefore, there are no worries about the film slipping out during processing. Besides, it is quite easy to wind the film in again after inspection. This type of tank is preferred by many photographers when 2¼" × 2¼" size films are used. Extraordinary care has to be taken to clean the plastic band—especially around the sprockets—after each use, because hypo is deadly poison for developer. The hypo was the last solution used, and the developer, the first at the next processing.

The tank itself is a round container with a detachable cover made of plastic or stainless steel. In the middle of the cover is a hole into which the solutions can be poured. Since this hole must be lighttight, the solutions do not run through it too quickly. It takes about 20–30 seconds for the tank to be filled completely. This time must be taken into account when estimating the total developing time, and it can make for difficulties when extremely fast-working developers are used. Therefore, with such a developer it is better to pour the developer into the tank in advance, place the loaded reel into the tank in total darkness, put on the cover, and then turn on the light. This method has to be used for some types of stainless steel tanks also, because the cover of this

type of tank does not have an opening. After pouring in the developer, or placing the film into the tank, and covering it, gently tap the whole unit against the table to release bubbles from the film.

Agitation in plastic tanks is done by turning a rod that comes through the center hole. In the case of the stainless steel tanks it is done by shaking the whole outfit back and forth. In order to achieve uniform results, agitation must be at regular intervals, such as for five seconds every minute or every half minute, depending upon the recommendations of the film and developer manufacturers. If you were to agitate a 35mm film continuously and evenly, developing marks would appear along the perforations.

If you develop only one roll of film in a deep stainless steel tank that is made for more than one reel, you should place the empty reels in the tank to keep the loaded reel from slipping up and down during agitation. I must emphasize that proper agitation is as vital for achieving good results as the other two components of the trinity, developing time and temperature.

Thermometers

Different types of thermometers are available for temperature control, such as a torsion type made of metal and the conventional glass thermometers. Those designed for use in the tanks described above can be slipped into the opening of the center rod or into the center hole of the tank cover. The temperature of the developer and the other solutions must be set before starting and it must be kept at the same level during development.

Of course, the thermometer is immersed in the developer, and we have to stir the liquid with the thermometer thoroughly if we wish to read the correct temperature. When the solution has reached the correct temperature, say 68° F., it is uncertain whether this temperature can be maintained after the developer is poured into a plastic tank. The temperature of the tank (loaded with

film) may be so much higher or lower (depending upon the temperature of the air to which the tank is exposed) that the initially correct temperature of the solution changes, because the liquid alters its temperature in its new surroundings. The situation is complicated by the fact that this temperature change does not happen at once. It takes four to five minutes for the temperature to reach the balance. Hence, we cannot calculate another developing time to compensate for the effect of the changed temperature.

To correct this failure, the loaded tank must be placed in the refrigerator for a somewhat longer period than is necessary for the solution to reach the correct temperature if the outside temperature is too high, or immersed into a lukewarm water bath (take care that the level of water does not reach the bottom of the cover) if the outside temperature is too low. This temperature balancing procedure must be done if the room temperature exceeds a 5° difference from the needed developing temperature.

The "place-in-the-reel" method is less delicate in this respect, because the temperature of the developer is fixed by the tank, and the mass of the reel-plus-film is negligible. Care has to be taken, however, when we use a deep Nikor tank with several reels, for this is no longer a negligible mass.

Larger Tanks

When developing sheet film, the volume of liquids used is overwhelmingly greater than the mass of films and hangers. Therefore, the temperature, once set, does not change noticeably when films and hangers are put into the tank, or when the developer is poured into a closed-type tank.

The agitation in a closed-type sheet film tank is somewhat less effective than in a 35mm or roll film tank (except the Nikor sheet film tank, which, along with its smaller-sized sisters, can be turned upside down), because the tank, filled up completely with liquid,

can be agitated only moderately to avoid spilling the developer.

Open-type tanks can be operated, of course, only in complete darkness—or at least darkness is required when the cover is off for agitation. During agitation the hangers should be lifted completely out of the developer and quickly immersed again twice. Meanwhile, the developer can be drained down for a short period, but alternately from the left and right bottom corners of the hanger. Although the cover of such a deep tank must be lighttight, we may fail to place it in its correct position and room light may damage the negatives. Therefore, it is advisable that the whole developing procedure be executed by the light of a green safelight or in complete darkness. Moreover, if we wish to develop by inspection, it takes at least one or two minutes for one's eyes to accommodate to the dim light of the dark green safelight. This is another reason why we should not turn on the room light during development.

Inspection itself is done after 75 per cent of the total developing time is over. After some experience we can judge whether the

Agitation of sheet-film hangers.

predetermined time should be maintained, increased, or shortened. During inspection we must not hold the negatives closer to the safelight than three feet, and for not longer than about five seconds. Since panchromatic films are sensitive to green light, though less so than to other colors, the negatives will fog if we extend the inspection for a longer time or hold the negatives too close to the safelight.

Darkroom Lamps

There are several types of darkroom lamps, but one feature is common to all: interchangeability of filters, either by revolving or exchanging, because various materials need different color safelights. Panchromatic films can be inspected by the light of the Series No. 3 (dark green) filter, orthochromatic films by the Series No. 2 (dark red) filter. For regular enlarging and contact papers the Series OA (greenish yellow), and for the variable contrast paper the series OC filter (orange-brown) must be used, (I use Kodak designations; other manufacturers use different designations for the same colors.) So the illumination of the darkroom is determined by the film or paper actually used.

Many people think that the walls of a darkroom must be painted black. This is an unnecessary precaution. The light of a 15-watt bulb behind the safelight filter is dim enough so that reflected light in the darkroom could not possibly affect the fastest panchromatic films even if the walls were painted sparkling white. On the other hand, it is definitely advantageous if we can see the things around us, instead of feeling blindly for them when the already dim light of a darkroom lamp is completely absorbed by dark walls.

Useful Hints for Processing

After development is completed, we pour the developer back into its container through the lip of the tank, or by detaching the

cover if the tank is a place-in-the-reel type. If it is a steady-type deep sheet film tank, we leave the developer in and pull out the film. Then comes a one-minute rinse in water or short stop. This step, of course, must be done in complete darkness or in safelight (Series No. 3, dark green for panchromatic films) if the cover of the tank is detached or the sheet film hangers are transferred into another tank that contains water or short stop. Some photographers are likely to use separate containers even for 35mm or roll film work instead of pouring the different solutions in and out. This method allows more exact control of developing time when a fast-working developer such as Ethol UFG, Baumann Acufine, or FR-X100 (not in 1:1 dilution) is used; when thin-emulsion films are developed; or when paper developer is used to obtain deliberately grainy graphic effects.

If developing is started in total darkness, a timer has to be used that can be set in advance for the duration of the developing time and whose mechanism can be started in complete darkness. When developing time is over, the timer gives a signal.

After the film is transferred into the hypo, immediate strong agitation is necessary for about 30 seconds. (This should also be done at the start of development and in the short stop.) After these 30 seconds, the cover of the tank can be removed, or the light can be turned on if the processing was done in open tanks.

Follow the instructions of the manufacturer of the hypo. And I repeat the warning: Don't remove the film from the hypo earlier than is suggested in the instructions even if the film is completely clear after 30 seconds. Agitate the film every minute or so, although this agitation does not have to be as uniform and exact as it must be during developing.

Washing and Drying

Washing of sheet films can be done in a large tray if you do

not have a separate tank for washing. Care must be taken that films are not damaged during this period even though the emulsion has been strengthened by the hardener in the hypo. Roll and 35mm films can be washed either in the tank or in a darkroom graduate of appropriate size. A rubber hose should lead into the hole in the center of the reel or be attached to the end of the agitating rod, if there is an opening in it, which leads the water to the bottom of the tank. To remove accumulated bubbles from the surface of the film, push and shake the reel several times during washing. In doing this with sheet film hangers, be careful not to damage films inserted into the nearby hangers.

Control of the temperature of the wash water is important, and there are several means available to achieve it—from the simple mixing faucet up to automatic equipment costing several hundred dollars. Since most amateur photographers will wish to use a mixing faucet, I must point out the pitfalls of this means.

First of all, steady temperature can only be achieved after a few minutes; even then this temperature may be altered by pres-

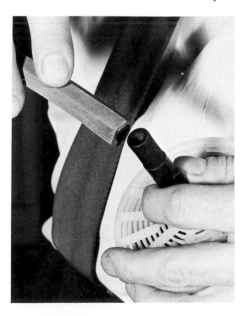

Hose fastened to center of reel.

sure fluctuations. If you turn on another faucet on the same line, the temperature may change as much as 10°. Once when I developed Ektachrome film, I was careless enough to rinse a funnel under the cold faucet of another sink while the film was washing. The result was a strong reticulation along the entire film, because of the sudden temperature increase of about 10° caused by the sudden drop of pressure in the cold water system.

Although units with automatic temperature control (by thermostat) are used mostly by production plants, an amateur photographer can purchase some lower priced and less fancy automatic units. Most of them are also provided with a filter, which is useful to prevent dirt from being introduced into the emulsion. Filters alone are quite inexpensive, and it is worthwhile to attach one to our photographic water supply even if we do not use an automatic temperature control unit. The filtered wash water (and processing solutions) may save nerve-racking time spotting out prints, especially in 35mm work. I will speak later about the filtering, mixing, and storing of processing solutions; now I would like to finish discussing the last steps of negative processing.

To facilitate drying the film and to prevent water marks, we should immerse the film in a wetting agent for about 30 seconds. Then hang up the film by a film-clip and attach another clip to the lower end of the 35mm and roll films. Sheet films should be attached to the clip by one corner. You do not need to attach another to the lower corner, but after a few minutes drain the accumulated water from this corner by touching it with two fingers.

Roll and 35mm films must be wiped off gently either between your index and middle fingers, which have been immersed previously in the wetting agent, or with a squeegee. In using a squeegee you must take care that it is completely clean and free of any foreign matter on the surface that will touch the film. If the squeegee is a plastic sponge type, it must be immersed in the wetting agent and pressed out thoroughly before it touches the film.

*(Left) Touch the corner of sheet film to remove water drops.
(Right) Wipe off film gently between fingers.*

Now the film is ready to dry. You won't have to wait too long
for a thin emulsion film to dry when the humidity is low. It takes
about 15–20 minutes. But when the humidity is high and you are
drying a high-speed film, which will, in general, have a thicker
emulsion layer, or a color film, which has three emulsion layers,
you may wait up to several hours for your film to dry. In this kind
of situation inexperienced photographers are likely to grasp the
window fan or the wife's hair dryer to force the film to dry. Such
intemperate action definitely will result in foreign matter being
buried in the emulsion, and white spots will appear in the print.

Instead of a fan or hair dryer, you may use a heated film drying
cabinet specially designed for photographic purposes, featuring a
filtered and perhaps dehumidified forced air supply. These film
dryers are available within wide price ranges. The simplest way
for quick drying, however, is the use of a quick-dry solution.

Mixing and Storing Solutions

In the foregoing you should have got an idea of how to use your equipment properly to get the best results. Avoiding failure, however, starts with the mixing and storage of the solutions. The most delicate solution in this respect is the developer. Most developers are supplied with detailed instructions for use and for mixing, but some are not. As the basis of how to mix and store a developer you have to know that some chemicals will likely redissolve or form clots upon a sudden increase of local concentration of another chemical. Others may be partially destroyed when the water temperature exceeds a certain level (in general 100° F.), but the most vital requirement during mixing a developer is to avoid any contamination with foreign chemicals, especially with hypo. Therefore, greatest care has to be taken to use absolutely clean darkroom graduates, stirring rods, funnels, and bottles. In connection with the storage of the developer, you have to know that it oxidizes if it is exposed to air—especially when it is in working solution.

The best way to avoid contamination is to use separate labeled darkroom graduates (made of enamel, glass, or plastic), stirring rods, and plastic funnels for developer and hypo. When we pour the chemicals in powder form into water amounting to about three-fourths of the final volume, we should do it slowly, stirring constantly. Initially, we must wait until the small portion of chemicals already poured has been dissolved completely; then we can pour in the next portion. Later on, when most of the chemicals are already dissolved, we can pour in the powder faster, but always stirring until all the chemicals are dissolved. We have less trouble diluting a developer, hypo, or short stop that comes in concentrated liquid form. If we use this type of solution, it is very useful to have a small graduated measure, which can also be used when we add replenisher.

I might also mention that, unlike developer in powder form, which requires warm water for mixing, there are some hypo bases that must be mixed in cold water. Therefore, *always read the instructions carefully* when you switch over from a well-known base to another.

After the solution has been diluted to its full volume, we pour it into its storage container. During this procedure we must filter all the solutions that will be used for negative processing, because sediments and impurities always remain deposited on the bottom of the graduate and suspended in the solution. If you put absorbent cotton or some other filter into the funnel you may be surprised at how much dirt will accumulate, even if the solution seems clear.

Filtering must not be done too many times during the life of the solution, and it would be excessive to filter solutions after each use. Moreover, this would mean an unwanted loss of the total volume. Care has to be taken not to shake up the working solution when we pour it into the tank because there is always sediment in

Put cotton in the funnel for filtering solutions.

Exclude air by compressing a plastic bottle.

the bottom of the bottle. Since we usually do not use all the volume of the solutions, we can easily pour out the clean part, and leave the sediment in the bottle. In general after five rolls of film have been processed the solution must be filtered.

It may be obvious that processed film soaks up a certain part of the developer. A 36-exposure roll of 35mm film absorbs about 20 cc. Therefore, the level of the developer in the bottle sinks if we do not replenish it. So the developer becomes exposed to the oxidizing effect of air. With certain sorts of developers or infrequently used developer, this can be disastrous to their keeping properties. It also means unexpected underdevelopment, a more serious problem. In these cases, we must discard the developer even if less film was developed in it than suggested and guaranteed by the manufacturer. To avoid this we must take care that the bottle is filled up completely, so no air is under the cap. We achieve this by using a plastic bottle, which can be compressed to force the level of the liquid to the top of the bottle.

Exposure to light can also decrease the effectiveness of the developer, so dark plastic bottles should be used. If replenisher is kept in one large bottle, we necessarily reach a point where we cannot compress the bottle far enough to exclude the air. Therefore, this liquid must be divided in small plastic bottles.

The working power of hypo and short stop is not affected by air; therefore, it is not necessary for the bottle to be filled up completely. However, it is advantageous to store these solutions in plastic bottles to avoid possible breaking of a glass container.

It is advisable that each kind of solution be stored in a different-colored or different-shaped container to avoid errors in use, and the containers must be labeled conspicuously. Adhesive tape can be used for this purpose, or a special kind of labeling tape, which can be purchased in photo stores. The label must indicate the name of the solution (perhaps abbreviated, for instance: Prom R, meaning Promicrol Replenisher), the date of mixing, and if it is not a replenished developer, the number of rolls or sheets of film developed up to date. In this way we are always informed exactly as to the degree of exhaustion, which is vital for the calculation of the developing time.

The exhaustion of short stop and hypo can be recorded by an easy system. We should prepare enough of these solutions to process as many films as we can process in a given volume of the developer. If replenisher is used for the developer, when the amount of replenisher used up indicates that so many films have been processed, the hypo and short stop must be discarded. For instance, if one 8-ounce bottle of replenisher is used up, we know that one quart of hypo and short stop and the 16 ounces of wetting agent must be replaced, because 10–16 rolls of film have been processed in these solutions.

Containers of other solutions also must be labeled, since so many different solutions are accumulated in the course of time in

a photographic darkroom (I take into account now the solutions for positive processing also) that mistakes are inevitable if the containers are not labeled exactly.

If you are a photographer who likes to experiment, a scale is a must. It is a useful device in any photographic darkroom. For instance, just one color processing solution—the hardener—decomposes after a week; the other solutions are still good. Would you buy a complete new kit and mix all the solutions again just because this one solution went bad? Not at all. You can buy chrome alum separately and mix a 3% solution—if you have a scale—and your decomposed hardener is replaced. This is only one example of how useful a scale can be in a darkroom, even if you use ready-to-mix chemicals.

When using a scale, be sure that it is zeroed in before each use. Never measure chemicals on the bare plate of the scale, but use a sheet made of plastic or celluloid. Do not forget to balance the weight of this sheet, or zero in the scale with this sheet on the plate.

Now you have learned some useful hints about negative processing equipment so I can tell you some other useful things about the materials that are used with this equipment.

3

Negative Processing Materials

Developers

Nothing is further from the goal of this book than to advertise any kind of product. There is no hard and fast scale by which to judge which product is superior. I can give you only general information about some of the most popular developers on the market. This information is based upon the question of which developer can be used for a certain type of film. The table below also indicates when a certain developer is not recommended for a certain type of film.

The letter R indicates that replenisher is available. If a particular developer is recommended for all types of 35mm and roll films, that means that it is a fine-grain developer. If a developer is not recommended for low-speed 35mm films, it has either a strong silver solvent effect or another feature that might destroy the high acutance of these films.

If a developer is not recommended for high-speed 35mm films, this indicates that the developer produces moderately fine grain. The developers recommended for only low-speed 35mm films are a class in themselves. These are one-shot developers featuring a

Recommended Film–Developer Combinations

		35mm low, medium, high speed			120 medium, high speed		sheet films
Agfa Atomal	R	X	X	X	X	X	
Agfa Rodinal		X	X		X	X	X
GAF Finex L	R	X	X	X	X	X	
GAF Normadol	R	X	X		X	X	
GAF Permadol	R						X
GAF Isodol	R						X
Baumann Acufine	R	X	X	X	X	X	
Clayton P-60		X	X		X	X	X
Cormac Unibath CC-1			X	X	X	X	X
Cormac Unibath CC-2		X	X	X	X	X	X
DuPont 16-D							X
Ilford Microphen	R		X	X	X	X	X
Edwal Super-20			X	X	X	X	
Edwal Minicol		X	X				
Edwal FG7		X	X		X	X	
FR X-22		X					
FR X-33C			X	X	X	X	
FR X-500					X	X	X
FR X-44			X	X	X	X	
FR X-100	R	X	X	X	X	X	X
Kodak DK60a	R				X	X	X
Kodak D-76	R	X	X	X	X	X	X
Kodak Microdol-X	R	X	X	X	X	X	
Kerofine 1500	R	X	X	X	X	X	
May & Baker Promicrol	R	X	X	X	X	X	
Plymouth Ethol UFG	R	X	X	X	X	X	
Plymouth Ethol TEC		X					
Neodyn Blue		X					
Neodyn Red			X	X	X	X	

high dilution of a quite energetic basic formula. Therefore, Rodinal (which is one of the oldest formulas) is suitable and recommended for low-speed films in high dilution.

Microphen and Clayton developers contain phenidone, replacing the formerly popular metol in a 1:10 ratio in the formula. Atomal and Promicrol use a quite rare developing agent, oxyethylorthoaminophenol, which executes a slight silver solvent effect

without the sharpness decrease and other unfavorable effects of paraphenylendiamine.

The keeping properties of a developer depend largely on how it is stored. As I said above, the bottle must be filled up completely, and the developer must not be exposed to light for a long period of time. Moreover, a developer loses its energy when it is not used for a certain period of time, even if it was stored properly, and even if it is a replenished developer. A replenished—and already used—developer must be replenished at regular intervals (two weeks) if no film is developed during this time. To do this we discard the amount that would be used up by one roll of film and pour in the same volume of replenisher.

It is often annoying for photographers who come back from vacation and find their first roll of film—developed in soup that was excellent one month before—turns out underdeveloped. Then they discard the soup and mix a fresh batch. Please! Discard the soup before developing the first roll. The keeping property of different developers varies, of course, but besides the individual features, many more factors influence it, such as the grade of concentration (concentrated stock solutions keep well), the storage temperature, enclosed air bubbles, and the initial air content of the water.

Hence, those photographers who do not develop enough film during the useful life of a developer may run into trouble. The one-shot developer is a good solution for these photographers, since they always can use a reliable fresh soup. No calculations are necessary to compensate for the grade of exhaustion by an increased developing time. Just open the vial, dilute as recommended, develop the film, and then discard the soup. Besides, you can develop two rolls of film at the same time, or one soon after the other, in the same diluted soup, since these developers have sufficient life for two developments.

Other developers, such as Rodinal, FR X-100, and Promicrol, can be used as one-shots. The concentrated stock solution such as Rodinal and FR X-100, or the ready-for-regular-use developer such as the case of Promicrol, should be diluted according to the instruction sheet. The instruction sheet also indicates the developing time that matches the grade of dilution.

It is a well-known fact that some developers give their best performance after at least one roll of film is developed in it. Some developers produce more pleasing results if they are "contaminated" by the oxidations and other products developed during the first processing.

For those who like to experiment and achieve extraordinary results, the following paragraphs contain a few developer formulas. But first we have to know what constitutes a developer, and what are its ingredients, features, and duties under certain conditions.

The developing agents determine the main features of the developer. But when developing agents are combined, their characteristics change. Usually one developing agent acts as a catalyst and changes the features of another agent. The most obvious example of this is the phenidone–hydroquinone combination. Phenidone alone and hydroquinone alone are not used as developing agents in developers. But phenidone changes the characteristics of the hydroquinone, and the combination makes a very good soup for developing films. A similar situation is produced in the case of the metol–hydroquinone combination, except that metol alone is also a very good developing agent. Similarly a certain amount of glycin added to a developer containing oxyethylorthoaminophenolsulfate or hydrochloride (the developing agent of Atomal) works as a catalyst for the latter.

The preservative has a dual role in the developer. First, it protects the developing agent from the oxidizing effect of the air.

Second, if it is used in larger concentration than just for plain protective duty, it dissolves silver to produce finer grain structure. Sodium sulfite is used for this purpose. Since sodium sulfite is slightly alkaline (pH 8½), metol works well with it, and the addition of other alkalies to the solution is unnecessary. (Metol works best in a solution with a pH index of 8). To produce the silver dissolving effect, sodium sulfite (desiccated) has to be in a concentration of 3 or 3½ ounces per quart.

The alkali in the developer increases the working speed of the developing agent. Some agents work very slowly or not at all at the pH 8½ of sodium sulfite. Therefore, other substances have to be added to the solution to increase its pH level. But we have to be very careful when increasing the pH level of the solution, because a high pH level causes coarse graininess, and the pH index of a fine-grain developer has to be under 11. Therefore, usually mild alkalies, such as borax, or tribasic sodium phosphate, are added to fine-grain developers, or a small amount of sodium carbonate (less than ⅛ ounce per quart).

Restrainers, such as potassium bromide, are used in some developers to keep the fog level low, or to maintain more equal developing times during the life-span of the developer. To explain this latter phenomenon we have to know that some developing agents are very sensitive to the bromide that is produced during development if the solution does not contain any at the start. If it does contain the bromide, the difference between the bromide produced and the amount of bromide started with (7–15 grains per quart) is very small and, therefore, does not change the working condition of the developer. Metol is not sensitive to bromide, so it works quite evenly without any initial bromide and does not produce fog.

Silver solvents other than sodium sulfite are incorporated in some fine-grain developers. One of them is potassium rhodanide. Its normal quantity is 15 grains per quart.

To prepare developer solutions, be certain that metol is dissolved first, if there is any in the formula, because it will not dissolve in the presence of sodium sulfite. After metol is dissolved, add small amounts of sodium sulfite slowly while constantly stirring the solution. If sodium sulfite is added suddenly to a solution containing metol, the metol will precipitate and not redissolve. Water temperature should not be higher than 100° F., because sodium sulfite decomposes at higher temperatures. Each ingredient should be added after the preceding one has been completely dissolved. The following are some useful developer formulas.

Phenidone–Hydroquinone Developer

Sodium sulfite, desiccated	3½	ounces
Hydroquinone	77	grains
Borax	46	grains
Boric acid	54	grains
Phenidone	3	grains
Water	32	ounces

Developing times at 70° F. 8–15 minutes.

This formula is similar to D-76, but instead of metol, phenidone activates the hydroquinone, in spite of its small concentration.

W. Beutler's Formula (Neodyne Blue)

Solution A

Metol	155	grains
Sodium sulfite, desiccated	1¾	ounces
Water	32	ounces

Solution B

Sodium carbonate, desiccated	1¾	ounces
Water	32	ounces

Working solution: 1 part A plus 1 part B plus 10 parts water. Developing times at 65° F. 7–10 minutes.

The most important feature of this formula is that it works on the surface of the emulsion. In this way it achieves maximum sharpness, because the deeper the image is penetrated, the less sharp it is. We can achieve this surface developing effect by using metol, which works quickly in a highly alkaline solution containing no potassium bromide. The shadow details on the surface appear at the same time as the highlights, and the highlights become heavier and heavier during development. Development should be stopped when the highlights achieve the necessary density. During the development, hydrogen bromide is formed (providing the same effect as potassium bromide), and as a result of this, metol becomes a deep developer. But because a deep working developer cannot provide the required sharpness for more than one use, it must be discarded afterward.

Another way to achieve the surface developing effect of metol is to hinder the penetration of the solution into the depth of the emulsion. This is achieved by a high salt concentration in the solution. To avoid the silver-dissolving effect of sodium sulfite, kitchen salt was chosen for this purpose. The formula is:

Salty Developer

Metol	46 grains
Sodium sulfite, desiccated	1 ounce
Kitchen salt, not iodized	1 ounce
Water	32 ounces

Best working temperature is 80° F. and the developing time 6–13 minutes.

The high temperature increases the working speed of the developer, and in this way development is completed on the surface before it penetrates deeper.

Another surface developer formula that works in a very interesting way is the formaldehyde developer (author's own formula).

Formaldehyde Developer

Metol	77 grains
Sodium sulfite, desiccated	3½ ounces
Potassium metabisulfite	124 grains
Paraformaldehyde	93 grains
Potassium bromide	7½ grains
Water	32 ounces

Developing time 3–10 minutes at a temperature of 76° F.

The paraformaldehyde combines with the sodium sulfite and forms sodium hydroxide, a very strong alkali. Metol works, as I mentioned before, as a surface developer in a highly alkaline solution containing little potassium bromide. The other function of the paraformaldehyde, which is in excess in the solution, is to harden the emulsion, thereby hindering the agglomeration of grains during development. This enhances the fine-grain effect, but the developer is not a pronounced fine-grain developer because of its high pH index. Therefore, it should be used only for developing low-speed, fine-grain films. The most remarkable feature of this developer, however, is that it is extremely powerful, and because of this power it transforms slower films into high-speed ones without excessive loss of grain quality or increase in contrast. It raises the film speed about five times without pushing.

Metol–Potassium Rhodanide Developer

Metol	93 grains
Sodium sulfite, desiccated	3½ ounces
Borax	46 grains
Potassium rhodanide	15 grains
Potassium bromide	7½ grains
Water	32 ounces

Developing times at 65° F. 12–16 minutes.

Potassium rhodanide works as a silver solvent substance in a developer and in this way renders fine grain in a negative. Its silver solvent ability is much greater than that of sodium sulfite. A

yellow stain is sometimes deposited on the surface of the film but this can be removed easily by wiping it off with a sponge or chamois. The disadvantage of this developer is that the exposure must be increased about one-half to one full f/stop.

Kodak Developer D-76 (Modified)

Metol	31	grains
Sodium sulfite	3½	ounces
Hydroquinone	77	grains
Borax	124	grains
Boric acid	124	grains
Water	32	ounces

Developing times at 65° F. 8–14 minutes.

Freshly mixed developer tends to produce slight fog. To reduce this tendency, add a small amount of potassium bromide (three or four grains) to the solution. The boric acid in the mixture serves as a pH index stabilizer (at pH 8½).

The above formula is a derivative of the Kodak's D-76, which contains only 31 grains of borax and no boric acid, but the quantity of the other ingredients, the developing time, and the temperature are the same.

Promicrol-Type Developer

Oxyethylorthoaminophenol-hydrochloride	93	grains
Glycin	18	grains
Sodium sulfite, desiccated	3½	ounces
Sodium carbonate, desiccated	180	grains
Water	32	ounces

Developing times at 70° F. 6–12 minutes.

Replenisher

Oxyethylorthoaminophenol-hydrochloride	¾	ounce plus 46 grains
Glycin	77	grains
Sodium sulfite, desiccated	2¾	ounces
Sodium carbonate, desiccated	2	ounces plus 46 grains
Water	32	ounces

After each roll of 35mm film (or equivalent surface of other sized films is developed, 20 cc (almost ¾ ounce) of replenisher should be added to the developer. When the amount of replenishment reaches half of the original quantity of developer after 25 rolls of 35mm film or equivalent quantities of other size films have been developed), the developer should be discarded.

Note about mixing the solution: As is usual for any developer, the ingredients should be mixed in the given order, and each should be added after the preceding one has completely dissolved. Glycin, however, dissolves completely only in the presence of sodium sulfite. Thus, do not attempt to wait until all the glycin has been dissolved; just go ahead and start adding the sodium sulfite and the solution will be cleared up quickly.

Metol–Sodium Sulfite Developer

Metol	77	grains
Sodium sulfite	3½	ounces
Water	32	ounces

Developing times at 65° F. 12 16 minutes.

Pyrocatechin Developer

Highly compensating developer for individual development of sheet or roll-film.

Solution A

Sodium sulfite, desiccated	22 grains
Pyrocatechin	118 grains
Water	32 ounces

Solution B

10% solution of sodium hydroxide

Working solution: ¾ ounce of A plus ½ ounce of B added to 1 quart of water. Developing time at 65° F. 10–16 minutes.

This developer can surmount extreme contrasts if overexposure and decreased developing time are administered. For instance, the filament of a lighted lightbulb can be made visible (and printable)

if the correct overexposure–developing time combination is found. This combination, of course, depends on the subject contrast and has to be determined by experiments. The working solution loses its activity in a few hours, and therefore after use it has to be discarded. (Test shots and final shot can be developed in the same solution, if they are done fast.)

The Short Stop

When the film is transferred into an acid solution, development is stopped immediately, since it can take place only in an alkaline solution. Short stops can be used several times, until the acidity "reserve" is exhausted. Exhaustion means that so much alkaline developer is transferred into the short stop that the acidity level of the solution becomes neutralized or actually alkaline.

To prevent this danger, some reagents indicate their exhaustion by a change of color. Then the short stop has to be discarded. If we use another kind of short stop than the indicator stop bath, we must take care that the solution smells definitely of acid. If it does not, it has to be discarded.

Of course, another method was mentioned above: to discard the short stop (and also the hypo) when a certain amount of film has been processed in the developer (either with replenishment or without) and is recorded on the label of the developer.

Hypo

Usually, the various brands of hypo can be used for fixing both films and papers. However, the dilution ratio for films is different from that for papers. The hypo for films is much more concentrated. Some hypos cool off during dilution. Therefore, to ascertain the proper rate of dilution, read the instructions printed on the container carefully.

Sometimes the name of the hypo printed on the label does not

indicate for what purpose the hypo can be used. For instance, the label may merely read: "Fixer." By reading the instructions you can find out that it is a plain sodium thiosulfate, which has to be mixed with other chemicals to make it a hardening or acid bath. So I recommend you read the instructions not only before you use the chemical (this rule is valid for any kind of chemical when you switch over from one to the other), but before you buy it, to be sure that you buy what you want.

As an example, if you read only the name of FR's Instant Fixol, you can easily suppose that this product is a rapid fixer—and it is. But to be effective it has to be poured into one of the one-time developers after developing is completed. Then the developer is converted into a fixing agent that has to be discarded after use.

Some developers cause discoloration of the fixing solution soon after even the first use. The previously colorless solution turns more and more yellow as more and more films are processed in it. This discoloration does not affect the effectiveness of the solution at all. In the case of film development (at least for most amateurs) a hypo tester is of no value, because according to the "record-on-the-label" method we know exactly when the hypo must be discarded.

Hypo eliminators may be useful, since if a print turns yellow from insufficient washing, you can make it over, but you cannot replace your precious negatives if they turn yellow (or show other effects) after a year or two from lack of proper and sufficient washing. To prevent this disaster hypo eliminator can be used. This neutralizes the acidity of the hypo remaining in the emulsion and helps the silver salt to dissolve more rapidly, since salts generally dissolve less efficiently in an acid environment.

It is only incidental that the hypo eliminator shortens the washing time to five to ten minutes. More important is the security of knowing that hypo is removed from the emulsion. For instance,

you may guess that a half hour washing for modern thin emulsion films will be enough when the temperature of the wash water is low (in winter), because for some reason you do not want, or are unable to use, a mixing faucet. (Of course, in this case also you have to go down gradually from the 68° F. of the hypo to the perhaps 40° F. of the water. This may be done by placing the film in different containers filled with cooler and cooler water, or by turning off the warm water faucet slowly—meanwhile agitating the film continuously—if you use a mixing faucet, until it is completely off.) It takes much more time to dissolve the silver–hypo complex from the emulsion in cold water but the hypo eliminator makes the job easier. There are several products on the market, and one is as good as the other. Moreover, all can be used both for negatives and prints.

Wetting Agent

The previous statement is valid also for the wetting agents, which have to be used to prevent water marks on the film.

A simple, compact means of storing chemicals and materials necessary for negative development.

Because water always contains dissolved minerals (such as calcium), these minerals are caked onto the surface of the film after drying wherever water drops were present. To avoid this, after washing the film should be placed for a little while into a solution that contains a surface tension reducing substance. When the surface tension of a liquid is reduced, drops are less likely to form, and the liquid runs quickly down the surface of the hanging film. To minimize the amount of remaining solution, wipe the film off gently. The use of such a wetting agent is responsible not only for the prevention of drying marks, but for a shorter drying time, also.

Drying the Film

We can decrease drying time even more if we use alcohol or some other volatile substance that mixes easily with water. The substance penetrates the emulsion and replaces the water but evaporates quickly after the film is hung up. Actually, the small quantity of water in the emulsion is mixed with a much larger quantity of the substance, which is thus diluted in a negligible ratio. However, after several uses the substance becomes so diluted that it has to be discarded.

The dried film should be filed as soon as possible to prevent its being exposed to dust and dirt or to any mechanical damage. Especially delicate in this respect are 35mm films. Moreover, they tend to curl. To counteract this tendency, put the film in an empty bulk film box, rolled up emulsion side out, for about 24 hours. After this straightening period, the film can be cut in five or six frame strips and put in glassine envelopes.

Reduction and Intensification

Though modern methods and materials eliminate the danger of excessive under- or overexposure, some negatives may require subsequent treatment. The negative may require partial treatment,

i.e., only a certain area of the negative must be reduced or intensified. The sky area, for instance, can turn out too dense in comparison with other printable areas, so that it becomes completely washed out in the print and the clouds disappear in this whiteness.

To make the enlarging or printing procedure easier (to decrease burning-in time), we can reduce the dense area by skilled application of potassium ferricyanide and sodium thiosulfate (plain hypo) mixture, with the help of a small wad of cotton. I cannot imagine, of course, that a great area of a 35mm negative can be safely treated by local application of reducer; therefore, this procedure is reserved for larger size negatives, such as at least 4″ × 5″. On the other hand, because 35mm films are developed for a much softer gradation and in more compensating developers than the larger ones, it does not occur too often that we have to think about such a local treatment for small format negatives.

To prepare the solution, dissolve enough potassium ferricyanide in one pint of water so that the water shows a color approximately like that of your dark yellow filter. (Or, more exactly, prepare a 10% solution if you have a scale.) This is the stock solution A. Stock solution B also dissolved in one pint of water contains about the same volume of hypo crystals as the volume of the potassium ferricyanide used. You can prepare a fast acting strong solution when you mix the two solutions equally. The more you dilute this strong solution with water, the lighter will be its color, and the slower its action.

When you reach the color of your light yellow filter, the reducer can be used for clearing highlights of prints without affecting the other tonal qualities of the print. This means that the solution is very weak. After some experience and trial on worthless negatives and prints, you may estimate the speed of the solution from its color. In any case, if it works too fast, you can dilute it further. Conversely, you can add some more stock solution, if you find it

works too slowly. The stock solutions can be stored for a long time, but when they are mixed together, the useful life of the mixture is only a few hours. For either local or full reduction or intensification, the negative has to be immersed in water for at least ten minutes to soften the emulsion. Moreover, the emulsion should be free from hypo, especially when intensification is to be done.

Potassium ferricyanide reducer is often called Farmer's Reducer. This type affects the less dense areas first. Another type of reducer, ammonium persulfate, acts conversely, so it can be used to decrease negative contrast. Be careful with this reducer, because it has subsequent effect, so your negative image may be reduced too much if you do not stop the treatment in time.

When using intensifiers, do not expect action on those areas of the negative that are lacking in detail due to underexposure. However, intensification is a useful means to build up printable density in underdeveloped negatives. Some of them increase graininess; therefore, they should not be used with 35mm negatives. Both intensifiers and reducers are poisonous, so keep them out of the reach of children.

If change of contrast in 35mm negatives is required, you can find a useful method (redevolpment) described in one of my other books, *Improved 35mm Techniques* (Amphoto, 1967).

PART II
POSITIVE PROCESSING

The Procedure in Principle

When we turn a black-and-white negative into a positive print, we do what we did when we produced the negative; we reverse the tonal qualities of the object (in this case the negative) either by enlarging or by contact printing.

It seems a very simple procedure. The only trouble is that our secondary object, the negative, reproduces the tonal qualities of the original object inexactly. In addition, the positive material reproduces the tonal qualities of negatives even less exactly.

As I mentioned in the first chapter, though modern films are able to surmount tremendous contrast differences, there is a limit to this ability; and the ability of photographic papers is even more limited. On the other hand, even though the general contrast of an object or a picture may be normal, there may be some parts in it that are much over or under this "normal" contrast. Moreover, despite the probability of getting the correct exposure almost automatically (by use of a reliable exposure meter), and achieving an almost uniform density of the negatives (with the help of equally reliable compensating developers), this is accepted as uniform only for the eye, not for photographic paper. Therefore, two main

features in the individual negative determine the procedure by which we reproduce or, at least, approach in the print the original tonal qualities of the subject, contrast, and density.

I do not necessarily mean that we have to reproduce tonal qualities exactly as we comprehended them in nature. I mean a reproduction that gives an illusion of our natural comprehension. Departing from this idea, we may not even wish to reproduce the original tonal qualities of the subject, but prefer to transform them in order to achieve a more pleasing result or a special effect.

The two features of the negative previously mentioned have much to do with our effort to effect this transformation successfully. In many cases we have to think about this special rendition before we push the shutter release button. This action is beyond the objective of this book, but I can state that without previous determination we can change the contrast rendition of a negative by choosing a certain grade of paper. In this way we are able not only to alter existing tonal qualities, but—marvel of marvels—we can influence deviations of the negative contrast into a correct or pleasing rendition. We can turn a too soft negative into a correct print by using a "harder" paper, and we can balance the great contrast of another negative by using a "soft" paper. The positive procedure is quite flexible, and we can almost always find the proper grade of paper to obtain a uniform print contrast for a given negative.

The other feature of the negative—the density—influences the overall exposure of the paper. Here, as well as when taking the photograph, you determine the exposure by two components (at least in projection printing): the $f/$stop of the enlarger lens and the duration of the exposure.

Basically and theoretically, the positive procedure is more simple than the actual picture taking negative procedure. Moreover, more controls are available for correcting or changing rendition. And it

is no small advantage that the entire procedure can be done over easily when failure occurs.

Among the controls—beyond the selection of the proper paper grade and the determination of the exposure—dodging and burning in are quite effective. These two means extend the limited contrast rendition ability of photographic paper on both sides of its gradation curve.

I could say that the contrast and the darkness of a photographic print depend upon the subject, but it is not quite so. Since contrast and darkness cannot be measured by inches or ounces, one person may prefer a softer rendition than another, or a lighter print rather than a darker. So one's taste can be developed to a certain style, and this determines how the above mentioned controls should be used. I can imagine that for the same negative one printer would use a harder grade of paper than another, or would expose 25–30 per cent longer. But beyond individual taste, one must always strive to obtain full details in the dark and the highlight areas of the print, unless some special rendition is desired, such as silhouette or high key.

When a style has been developed, we use our controls to obtain a print quality consistent with this style. It must not be overlooked, of course, that this style should be attractive not only to ourselves, but to others as well.

Besides the controls during projection, there are also controls during the chemical phase of print production. The dark or light appearance of a print can be regulated within certain limits during the development. However, most photographic papers require a certain optimum and minimum developing time. Therefore, the exposure should be of such length that the required print "density" will be obtained in the optimum development time. This is the ideal. Some deviation from it, however, is not fatal. It is preferable to deviate from the optimum development time by extending

it rather than shortening it. The result of the latter—with most papers—is a print with gray blacks and a lack of crispness.

On the other hand, an extended development time does not affect the "color" of the print, though it may affect the highlights in the form of fog. *Moderately* extended development may bring out *more* highlight detail without bringing out deeper than necessary blacks in the shadow areas, if the extended development was necessary to compensate for an overall underexposure.

The situation is quite different when the lack of highlight details is due to an improper choice of paper grade, or insufficient burning in. In this case, extended development would result in a much darker print than required. Hence, in this and any other situation where the highlights would presumably be too light, we can help to develop those light areas faster by localized treatment with hot concentrated developer. Meanwhile, we should take care that the hot developer does not affect other areas.

Treating the print with hot developer.

Treating the print with reducer.

Conversely, we can lighten areas that turned too dark, by local treatment with diluted reducer, after the print is transferred into the hypo.

The positive process is done in two main steps. First, projection of the negative image (or printing it by contact) onto the light sensitive material (paper or film). In this step, a latent image is formed in the positive material, which is made visible in the second step.

The second step is the development of the visible image and the procedures related to it, *i.e.*, short stop, fixing, washing, and drying.

As you can see, the entire procedure is, in theory, the same as it was when we were producing the negative image, although some deviations have been incorporated, such as the possibility of regulating density and contrast.

Let us see now how this theory is applied in practice.

5

Equipment for Processing Prints

Contact Printing

There are two main types of contact printers. One is designed for sheet film; the other is designed and used for strip film. The sheet film printer is more complex and versatile than the strip film printer. It features possibilities for varying light intensity over different areas of the film surface. In this way density differences within the negative can be balanced, or when more than one negative is printed at the same time, density differences of the various negatives can be equalized. This can be done by putting pieces of transparent paper onto the appropriate areas of the glass plate between the light source and the glass plate that holds the negative. This is a method of controlling the light distribution in the most simple contact printers.

The more complex units are provided with several lightbulbs, and by switching bulbs off or on under the negative, you can control the light distribution in such a way that dense areas of the negative receive more light. You can shade thin areas by placing transparent paper on the lower glass plate or by turning off the bulb under that area. These procedures substitute for the dodging and burning-in techniques in projection printing, although their effect is limited.

The larger the negative format, the greater is the possibility of

control, but since most amateurs do not handle 8" × 10" negatives, their efforts are confined, for the most part, to printing and equalizing the different densities of four 4" × 5" negatives on a single piece of 8" × 10" paper at a single exposure.

Contact printers for strip films are less complicated and are designed to make contact prints of an entire roll of film (either 2¼" × 2¼", 2¼" × 3¼", or 35mm) on the same piece of 8" × 10" paper. Density differences of the individual negatives are obviously more frequent among the, perhaps, 36 individual frames of a 35mm roll than among only four 4" × 5" negatives. Still, these differences can be easily equalized by masking thin negatives with cardboard and allowing additional exposure for dense negatives. The overall exposure time has to be determined according to the density of the majority of negatives.

When using variable contrast papers, different frames can be exposed through various filters to allow individual contrast control.

Since this kind of contact printer is placed under the enlarger in order to make the exposure, projection paper must be used. In order to equalize density differences of different frames, it is generally best to use normal or slightly soft paper.

For the other type of contact printer, with its self-contained light source, contact papers are available in four or five contrast grades. Contact papers are much less sensitive than projection papers, so more exact exposures can be maintained during a relatively longer exposure time. However, if the negative is a little bit dense, or mass production from one negative is required, the use of the more sensitive enlarging paper seems to be a more favorable solution.

Enlarging

All enlargers work basically in the following manner: The beam of a powerful light source is projected through the negative,

which is held flat in a carrier. The evenly lighted negative image is projected through the lens, which casts the image onto light sensitive paper, held in place on an enlarging easel. The farther the paper is from the lens, the greater is the degree of enlargement. Therefore, the entire enlarger head can be moved up and down on a vertical bar. When the lens–paper distance has been changed, the lens must be focused.

The actual exposure is accomplished, mostly, by switching the light on and off. In addition, the lens is provided with a diaphragm, which enables you to keep the exposure time within favorable limits.

I would like at this point to give you a more detailed explanation of the enlarging apparatus at work.

The light source is situated at the upper part of the enlarger head (called the "lamphouse"), which is painted white or silver on the inside, not only to increase reflectivity, but to make the relatively small spot of the bulb, in effect, larger. Because the lamphouse is shaped in such a manner that the bulb can be placed in its focus, quite even lighting can be produced. To provide the maximum in even illumination, an opal bulb should be used. These come in several strengths, such as 60, 75, 100, and 150 watts. Use only the bulb that is recommended for your enlarger, or overheating may occur. A slightly stronger bulb may be used occasionally, but care must be taken not to inspect the image on the easel for too long a time.

Besides incandescent bulbs, cold light (fluorescent) illumination also exists. This is quite soft and even. The Omega Enlarger, for instance, is provided with an interchangeable lamphouse, so it can be used with either cold light illumination or regular enlarger lamps.

The already even illumination provided by the source–lamphouse complex is more evenly distributed either by an opal glass

plate, or, more frequently, a condenser lens. The opal glass provides a softer overall illumination and allows a softer rendition of negative contrast. Therefore, it may be advantageous to use this device when portraits are enlarged.

The condenser is made of one or two plano-convex lenses placed between the light source and the negative, very close to the latter. Its diameter must completely cover the entire surface of the negative. The condenser lens must also be close to the focal length of the enlarger lens, and since the enlarger lens bears a direct relationship to the negative size (for 35mm negatives, 50–60mm; 2¼″ × 2¼″, 75–85mm; 4″ × 5″, 125–135mm), the condenser lens is also related to the negative in this respect. Thus, in enlargers that handle a variety of negative sizes, when the lens is changed, the condenser must also be changed. This is done, for instance, in the Omega Enlargers.

On the other hand, some enlargers designed for limited multipurpose use (for instance, from subminiature to 2¼″ × 2¼″) do not make use of interchangeable condensers. The condenser remains in place when the lens is changed from 75mm to 50mm because the slight loss of strength of the illumination is not great enough to warrant the construction of a much more complicated unit.

In some enlargers the light source can be raised, lowered, or moved sideways to provide perfectly even illumination for the entire field. This should be done when the enlarger is first purchased. The procedure is quite simple. Just place the enlarging easel or a piece of white paper on the baseboard of the enlarger, place a negative in the carrier, and raise the enlarger head to a point at which the negative is brought into focus. Remove the negative, and move the lamp until you have it in a position that illuminates completely evenly the entire rectangle of projected light. Tighten the tightening device, if there is one, and your lamp is permanently adjusted.

Right under the condenser is the negative carrier, except in those enlargers in which there is a color drawer between the condenser and the negative carrier. This is a most critical part of your enlarger. Its function is to hold the negative completely flat, from corner to corner, even when the negative is exposed to heat. This last statement explains why the construction of the negative carrier is so important. We have no difficulty with glass negative carriers, which obviously do not allow the negative to curl. But glass carriers have a drawback: they tend to pick up dust and dirt easily, which is sometimes not easy to remove.

Using a glassless carrier eliminates this worry, and one need only keep the negative and the bottom surface of the condenser dusted. But curling becomes a problem. Stopping down the lens will increase the depth of field of the projected image, but the fact is that the film is curling *during* exposure, due to the gradual increase in heat. This is the main cause of unsharpness in some areas of the projected image.

This problem can be overcome by determining how hot your negative carrier and condenser get during exposure. If you find they grow too hot after a certain period, do the following: Focus after about 30 seconds of warming up. In this 30-second period, the film assumes its final shape and stops moving. When you place the paper onto the easel, don't switch off the light of the enlarger, but protect the paper with the red filter. Then push the red filter aside. To avoid vibration from removing the filter, hold your hand under the lens for a few seconds after the filter is removed and make the actual exposure by removing your hand from the path of the light.

If you use an automatic timer, the red filter should be removed the instant the light is switched off. The exposure should then be made by timer immediately, waiting, of course, a few seconds for any vibration to subside.

*To avoid vibration after removing the filter, hold hand
or dodging device under lens for a few seconds.*

The amount of vibration depends on a number of factors in-
cluding the construction of the enlarger, the elevation of the en-
larger head, and last, but not least, how smoothly you push aside
the red safelight filter. Remember, vibration may also occur during
exposure if you are careless and lean against the table on which
the enlarger rests, or walk around the room while the automatic
timer makes the exposure. The result of vibration is a greater or
lesser degree of unsharpness throughout the print.

The negative is held firmly between the two parts of the carrier
by strong springs, or by the weight of the condenser or both. If we
wish to advance the negative one frame (in the case of film strips),
the pressure must be released to avoid scratching the negative.
Some enlargers use the bottom surface of the condenser lens to
hold the negative flat in a one-piece glassless carrier.

Regardless of the type of negative carrier, or even if the con-
denser lens is used to hold the negative flat, greatest care must be
taken to keep the film gate, all surfaces that come in contact with
the negative, and the negative itself free from dirt. Cleaning fluids

should be applied occasionally to film and glass surfaces, and it is wise to use a vacuum cleaner to remove any dust accumulation from the film gate. Moreover, every time the film has been changed in the negative carrier, or the negatives advanced, the film and glass surfaces must be brushed off. In the strong light passing through the film gate, otherwise invisible dust becomes very conspicuous when one looks into the film gate in the same plane as the negative surface. This dust can be easily removed with a fine, thin brush.

Some enlarger constructions permit using a tiltable negative carrier for correcting convergent lines of the negative. In other cases, the angle of the lensboard can be tilted in relationship to the negative carrier, which has the same effect. In addition to this kind of construction, the entire enlarger head can usually be tilted so we do not have to tilt the easel. Sometimes the enlarger head can be tilted to 90° so that vertical projection is possible. Vertical projection is of value when extreme blowups are to be made, and the column is not long enough to allow such magnification, even if the head can be swung outward to allow projection on the floor.

When negatives smaller than the largest acceptable format are used in an enlarger, masks should be used, or the entire carrier should be changed. There are also carriers with adjustable masks.

Brush off the negative carrier.

The proper masking of the negative may prevent slight fogging of the print. This slight fogging manifests itself in less clear highlights, or in decreased contrast. The same result occurs when light leaks in around the negative carrier or through the ventilation holes of the lamphouse, and reflects from some light-colored or shiny object onto the projection paper. In any case, beware of shiny objects around the projection area. When you are cropping, stray reflection from the light of the cropped out area may be reflected onto paper and cause unexpected exposure.

A negative carrier with built-in adjustable masks helps to prevent such a failure, since you determine the cropping on the negative itself by closing the masks to form the proper shape.

Below the negative carrier is the lens, which is attached to the rest of the unit by means of a bellows or a barrel. Actually, the lens itself is placed into a lensboard. This is either removable together with the lens (in interchangeable lens enlargers), or the lens can be screwed out of the lensboard when cleaning is necessary. Some enlargers hold two lenses at the same time, and the lens in use can be shifted into position by means of a sliding lensboard.

Different means are employed to vary the length of the bellows for focusing, such as rack-and-pinion, friction wheel, or micrometer. If the lens is attached by a barrel, the focusing is done by turning the barrel.

In autofocus enlargers, focusing is entirely automatic, if the magnification selected is within the range of the coupling. These enlargers adjust the focus to magnifications up to 8X to 10X. When greater magnification than is permitted by the autofocus is required, focusing must be done manually, as in regular enlargers.

If you use the autofocus enlarger within the range of its automatic capabilities, however, you must adjust the position of the enlarger head on the column according to the thickness of the enlarging easel used. Sometimes the column itself can be adjusted to

the thickness of the easel. In any case, the zero position is marked, and this position is based on projection onto the plain baseboard. Study the directions carefully in this regard, because the adjustment is sometimes a very tricky business. The same careful synchronizing of the focusing system is necessary in order to avoid misuse. Another warning: If you intend to buy a lens other than that supplied with the autofocus enlarger, or if you try to use your camera lens, you can use only that focal length for which the enlarger is designed. For instance, if you use your 55mm camera lens with an autofocus enlarger that is designed for a 50mm lens, it will not be autofocus at all. The 5mm difference in length is more than enough to keep your unit from operating properly.

Nowadays, enlarging lenses feature click-stop diaphragms so the proper f/stop can be set easily in the dark without seeing the figures. If we use an older type of lens, or a camera lens, which may not have this feature, we can attach a small lighting device available in camera stores, or we can use a flashlight or small penlight covered with two or three layers of red transparent paper to see the f/stop figures. In any case, a red flashlight is always useful in a darkroom.

The image of the negative is projected by the lens onto the enlarging easel, which holds the light sensitive paper flat. There are several types of easels. One type accepts only one specific size of paper, another has four different frames incorporated in both sides of the same unit, while a third has adjustable frames, to accept any size of paper up to 8" × 10" or larger.

All these easels provide a white border to the print, and in some of them even the width of this white border is variable. Sometimes from one darkroom session to the other we may forget the proper setting of the adjustable masks to provide a uniform border on all four sides of the print, even if our easel does not feature a choice of the width of the border on the fixed side of the

frame. If it does, then it is even more difficult to obtain the same width of the white borders on the mask sides. Therefore, I suggest that you make a note on the back of the easel of the figure with which the adjustable mask must be in line to get the required border width. On my easel, for instance, the pointer of the mask must be in line with the figure ⅜ inch smaller than the actual print size; this means that I have to place the masks to the dimensions of 7⅝″ × 9⅝″ for an 8″ × 10″ print to obtain the same border on all four sides of the print. Another solution is to mark intersection points of the moveable masks on the white surface of the easel for each print size used. In easels featuring all-around variable borders, you may figure out your own system for maintaining uniform borders, depending upon the construction of the easel.

You can obtain uniform borders, of course, only if you cut the paper exactly. Since in the dark it is sometimes not easy to recognize the lines of the print trimmer, you can make the job easier by sticking white adhesive tape about two inches long and one-quarter

Attach white tape to the print trimmer.

or one-half inch wide along the lines most often used. For instance, in this way you can mark the 7-, 5-, 4-, and 2½-inch lines. This marking helps not only to visualize the required measure, but you can definitely feel when the edge of the paper reaches the edge of the tape.

After this practical little deviation from the main topic I will now go back to the procedure of enlargement. You have now completed the following steps: The negative is in the carrier, and it is dustless; the proper cropping has been determined by appropriate elevaton of the enlarger head; the lens is focused on the easel; the lens is stopped down to a medium $f/$ stop, required by the overall density of the negative combined with the preferred exposure time (which means a time long enough to allow dodging, but not unbearably long); and in accordance with the criteria for selecting the proper contrast grade of paper, as outlined in the previous chapter, I assume that you have selected a paper.

The question now is how long, exactly, should the proper exposure be? As in the case of selecting contrast grades (or the proper filter, in the case of variable contrast papers), "experience makes the master." The test strip method can be used to determine the proper exposure. For instance, if we guess that a ten-second exposure is necessary, we put a strip of projection paper under the protection of the red safelight, on an area of average density of the projected image. We then make exposures of 6, 8, 10, 12, and 14 seconds by sliding a piece of cardboard down the length of the strip at 2-second intervals, starting when the sixth second has elapsed, and switching off the light at the end of the fourteenth second.

Develop the test strip for the recommended time and examine the result after about 20–30 seconds fixing under regular room light conditions. You may find that instead of the estimated 10 seconds, 12 seconds will provide a more favorable exposure time, or you may find that the exposure should be shorter. You then make the exposure on the full size paper.

To maintain the result of the test strip exposure, the time must be exactly the same. Some very experienced photographers can count the seconds very precisely, but, for the most part, counting is at best unreliable, especially when long exposures are involved. To be really exact, use a timer.

We do not have to make new test strips when we change the magnification of the same negative if our enlarger features a scale that indicates the magnification figures. The following table gives information about the new exposure times related to various previous magnifications. Simply find the number 1 in the vertical column of the magnification you were using. Multiply the previous exposure time by the number you find in the same horizontal line under the rate of the new magnification.

Rates of Magnification

1	1.5	2	2.5	3	4	5	6	8	10
1	1.5	2.25	3	4	6	9	12	20	30
0.7	1	1.5	2	2.75	4	6	8	12	20
0.5	0.75	1	1.25	1.75	2.75	4	5.5	9	13
0.33	0.5	0.75	1	1.25	2	3	4	7	10
0.25	0.33	0.5	0.75	1	1.5	2.25	3	5	7.5
0.16	0.25	0.33	0.5	0.7	1	1.5	2	3.5	5
0.11	0.16	0.25	0.33	0.5	0.7	1	1.3	2.25	3.25
0.08	0.12	0.2	0.25	0.33	0.5	0.75	1	1.75	2.5
0.05	0.08	0.11	0.16	0.2	0.33	0.5	0.6	1	1.5
0.03	0.05	0.08	0.1	0.15	0.2	0.33	0.6	0.7	1

See also in Appendix.

The timer is an electrical device that may be set to switch the projection lamp on when the timer is started and automatically switches it off when the time set on the dial has elapsed. Some very advanced timers are also wired into the darkroom illumination, which is shut off during the exposure and cut back on when the exposure is completed. Any kind of timer must permit the light to remain continuously switched on for focusing and examining the

projected image. Although such a timer is relatively inexpensive (the Time-O-Lite Professional, for instance, is reasonably priced), there are even less expensive devices available, which are capable of maintaining exposures. Besides the less complex timers, you can use a metronome for counting seconds, or the sound of a kitchen clock can inform you of how many "time-units" have elapsed. For maintaining uniform exposures, it is not necessary that the duration of the exposure should be determined in full seconds. Any kind of time-unit standard can do the job.

For determining the correct exposure time, several devices are available besides the test strip method. Some of them work by the test strip principle, but instead of an increase of exposure time for each successive band, a gray-scale device is placed on the paper, which allows a gradual exposure increase through progressively more transparent segments—all by a single exposure. After development, the desirable appearance of one segment should be apparent, and the number appearing within that segment indicates the exposure time necessary to obtain the same result in a full size print.

Besides these simple, but very effective aids, there are more complicated devices such as calculators and meters. Some of them are completely automatic, using the electric eye system, but these are useful only in large processing plants with a production line working method.

Not so long ago, an electronic dodging device was invented and produced. But devices of these types are of little value to the amateur, or even individual professionals, since less complicated and less expensive devices are satisfactory for their purposes.

We can obtain excellent results with simple dodging and burning-in devices, which are sold at photo supply stores for just a few dollars. These are made of red transparent plastic or celluloid. The entire projection area is visible during manipulation in both cases, with the protected area seen through the red plastic. The burning in

is executed through a variable size or interchangeable hole in the plastic. By changing the hole (by means of a rotating disc) or varying its shape, we can fit the device to the shape of the area to be treated.

Going back to enlarging apparatus, it is wise to ground the unit in order to minimize the dust attracted by static electricity. Some enlargers have a special screw for this purpose located somewhere around the base of the column. Actually, a grounded wire attached to any metallic part of the enlarger, especially the enlarger head, will do the job quite well.

After the exposure is made, the paper has to be developed. This procedure has to be done under the protection of the safelight recommended for the particular paper you are using. For standard

(Left) Burning in with the Willo device. (Right) Burning in with the hands.

Dodging.

enlarging papers a yellow-green safelight has to be used, and for
variable contrast papers a much darker light is prescribed. Actu-
ally, the yellow-green safelight can be used safely for variable con-
trast papers during the development, if the light does not strike the
paper directly. Therefore, the darkroom lamp, with a 15-watt bulb,
must not hang directly above the developing tray. It should be
placed no less than three feet away from it. Even in this diffused
light of the yellow-green safelight, the progress of the develop-
ment and print contrast can be judged more exactly than in the
direct light of an orange safelight. This deviation from the manu-
facturer's recommendation can be made because the paper loses a
great part of its sensitivity after immersion in the developer and
the outset of development. It should be remembered, however, that

dry variable contrast papers *cannot* be exposed in this light; around the enlarger area, the prescribed filter is a necessity. The number of darkroom lamps, of course, depends on the size of the dark-room; but I recommend the two-lamp method—one at the enlarger and one in the processing area.

Marking the Trays

The trays and tongs used in processing must not be interchanged.

A lot of means are available to mark the trays with an indication of the purpose for which each is to be used. For instance, you can stick a piece of white adhesive tape on the outside of the tray and write the letters F or H (fixer or hypo), S (short stop), and D (developer), on the appropriate tapes in ink. Or you can paint directly on the tray in white or black ink—depending on the color of the tray—and cover the lettering with transparent lacquer or tape to prevent it from being washed off.

In general, the tray used for hypo will be the largest of the three, because quite a large number of prints may be accumulated in this tray. It is not necessary for the developing tray to be larger than the largest print format you intend to develop in it. However, if more than one print is to be developed at the same time, it is advantageous to use a tray somewhat larger than the print size.

Amounts of Solutions to Be Used

The volume of each solution is determined by a number of factors. Enough developer should be poured into the tray to insure uniform performance for the number of prints to be developed during a given session. As a rough guide, about twenty 8″ × 10″ prints can be developed in a quart of developer. The quantity of the developer, on the other hand, should be not more than can be safely handled in that size of tray without splashing over, and not less than enough to cover the print immediately upon immersion.

The following are recommended volumes for various tray sizes. I recommend *not more than:*

One quart of developer to an 8" × 10" tray

One-half gallon of developer to an 11" × 14" tray

One gallon of developer to a 16" × 20" tray

The quantity of short stop is not critical, but *at least* one-half gallon of hypo should be used in an 11" × 14" tray, and *at least* one gallon should be used in a 16" × 20" tray.

If you develop fewer prints than the developing capacity of the solution, you can store the fluid in a well stoppered, completely filled bottle. It can be kept there for several weeks. Plastic containers are very useful for this purpose, since the air can be removed from the bottle by squeezing the sides, thus reducing the amount of oxidation that will take place.

Separating the Tongs

To avoid mixing of tongs, you should use either different colors or different types of tongs for each processing solution. In the beginning it is wise to mark each set of tongs somehow. After a while, though, you will know, for instance, that the stainless steel tongs are for the developer, the bamboo for the short stop, and the plastic for the hypo.

Washing the Prints

After the prints are completely fixed, the chemicals must be completely removed both from the gelatin and the paper. There is no method of detecting when fixing is completed, and to complicate matters, as the solution becomes exhausted, more and more time is required for fixing. To make sure that all the silver halide has been transformed into a soluble silver–hypo compound within

a reasonable time, the two fixing bath method seems to be advantageous. I will discuss this method in the next chapter when I deal with the materials of processing.

Now the prints must be thoroughly washed in running water for a period of time prescribed by the manufacturer of the paper. This is usually one hour if no special treatment, such as hypo eliminator, has been administered. Care must be taken during this phase that the papers do not stick together and that the proper turbulence and drainage of the water is maintained. To assure this, the best solution is a print washer.

These devices are available in different constructions and in various price categories. Although the proper turbulence of the water is provided in most of these units, it is always advisable to make sure the prints do not stick together. They are especially likely to do this if more prints are washed at the same time than the washer was designed for. If you use the type of washer in which the prints are not kept in a constant circular motion, see that they are faced against each other alternately. In this way their tendency to stick is reduced.

The prints should occasionally be pushed by hand in order to release air bubbles that accumulate on the emulsion side of the prints. The entire sequence of prints should be changed, also, by turning them over from time to time, one after the other.

Complete fixing and washing of the prints preserves them for a lifetime; but when one or the other of the two is incomplete, yellow stain is inevitable. Sometimes this shows up even as the prints are being dried. This early yellow stain is probably the result of incomplete fixing, or allowing the print to remain in the developer for too long a time. In any case, the heat of drying is likely to bring the result of such a failure to light in a very short time, and, I am sorry to say, there is no way of correcting such a print.

Drying the Prints

Applying heat is the quickest method of drying the prints. Sometimes, if there are a great many prints to be dried, it is less time consuming to place them between blotters overnight.

Dryers are usually of drum or flat surface construction. The plain surface constructions are mostly twin dryers, with two ferrotype plates.

When placing the prints on the ferrotype plates, greatest care must be taken that no air bubbles are allowed to remain between the emulsion and the plate, if high gloss prints are required. It is helpful to immerse the prints in a wetting solution for a half minute before placing them on the ferrotype plate. Place them on the plate without draining and then squeegee gently with a rubber print roller under the protection of the canvas cover or a thin towel until most of the liquid is pressed out. Then apply the roller more and more vigorously until the print sticks firmly to the surface of the plate. In doing this, take care that the print does not slip and that you do not bend the corners of the print. If this happens, the print will almost inevitably split along the crease.

Prints will tend to slip if the ferrotype plate is too hot; therefore, the plate may have to be cooled off by holding it under the cold water faucet. At the same time, you can clean the surface of the plate. Then you can safely place the prints on it.

If matte or semi-gloss prints are desired, you must place the prints on the plate with the emulsion side up. In this way, the apron is in contact with the emulsion; therefore, it, too, has to be kept clean and free from lint and dust.

Double weight glossy papers are likely to show matte areas even when they are processed for gloss, so it is wise, for the sake of uniformity, to process them for a dull finish.

There is less manual work to be done when one uses a drum-type dryer. Simply place the print emulsion side up on the moving

apron when high gloss prints are desired. (Prints intended for a high gloss finish should be immersed in a wetting agent bath.) Continue feeding the prints into the machine until all the prints are in. The high gloss prints should separate from the drum by themselves after one circuit through the machine. If they do not, stop the machine immediately, using the built-in clutch, if there is one. If there is not, allow the print to make a second circuit. The prints should then fall into the collector basket. Make sure that the edges of the prints are not bent on the second trip through the machine. Stop feeding the machine the moment you realize something is wrong. Failures may occur at the beginning of the run, when the drum is not hot enough to do the job correctly. This can be prevented by turning the machine on a few minutes before beginning to feed the prints. If the machine does not dry properly on one run after it has reached its regular working temperature, slow down the speed of the drum with the built-in regulator.

When drying matte prints, you will have no trouble in this respect, since the paper side of the print will not stick to the drum. The amount of moisture remaining in the print is less critical in this process, too.

The dry prints—especially those on single weight paper—tend to curl. To diminish curling, you can either apply a print flattening solution before drying, use a print flattening machine (this is for professional quantity production), or place the prints, facing each other alternately, under pressure overnight.

It does not matter, however, whether or not the prints curl, if you intend to put them into a folder or an album, or mount them.

Print Mounting

For dry mounting prints on mounting boards, the most convenient method is to use a dry mounting press. Simply place dry mounting tissue of exactly the same size as the print onto the back

of the print. Touch the tissue for an instant with the point of a household iron, or a special tacking iron, at two opposite corners. Place the print on the mounting board and bend one of the free corners up a little, so as to be able to touch the corner with the hot iron. Repeat this on the other free corner, and the print will now be fixed to the board.

Next, place a piece of thin cardboard over the print for protection, and put the entire assembly in a preheated mounting press. Apply pressure for a few seconds, and the print will be sealed to the mounting board.

Since mounting presses are rather expensive, you may want to do the entire process with your household iron. Protect the print with a piece of cardboard and apply pressure from the center outward to the edges. Make sure that the heat does not exceed 275° F. This temperature is obtained approximately between the "silk" and "wool" settings on automatic irons.

6

Print Materials

Photographic Papers

It should be obvious that the most important of the materials used during the positive processing—the end result of the photographic process—is the photographic paper itself.

Even a beginner should know that a great variety of papers exists; and within the variety of brands, there exists a variety of sorts for different purposes.

A certain type of paper, regardless of the manufacturer, serves the same purpose, but, despite this fact, slight differences of features may give different results during processing. Therefore, I will point out some features in a comparative manner—where it is possible—in order to put the reader on a firm basis for using any kind of paper. The manner of my examination does not mean that one can expect the best possible results immediately when switching over from one type, or brand, of paper to the other. Experience is necessary to obtain the desired results under any conditions. My examinations and comparisons will, however, help in "tuning in" to a particular type or brand.

First of all, among positive materials, we can distinguish two main types of papers: contact and projection papers. As a third

group I will add positive films used for making black-and-white transparencies from the negative for projection.

The name introduces the manner of use: contact papers are used in contact printers, almost exclusively from 4″ × 5″ up. Since they are much less sensitive than projection papers and positive films, they can be processed in the light of a yellow safelight. Positive films have to be processed in red light. Contact papers are of significant value to the professional photographer, and the amateur can substitute projection papers for them.

The two main types of projection papers available in the United States are the conventional and the variable contrast types. Conventional papers can be processed under the light of a relatively light yellowish-green safelight, and for the variable contrast papers a much darker orange safelight is prescribed. But as I mentioned in the previous chapter, the yellowish-green safelight can be used with variable contrast papers under certain restrictions.

Papers—whether contact or variable contrast—have to be adjusted to the unalterable contrast rendition of the negative. Therefore, conventional papers are manufactured in various contrast grades (with some exceptions). This adjustment is achieved in variable contrast papers by the application of various different-colored filters.

Whether conventional or variable contrast papers are used, a certain comparative standard has to be set to give expression to the contrast rendering ability of the paper. This standard is expressed either by numerals or words, or both. Unfortunately, the expressive figures of the standard are not exact; deviations occur from one brand to another. Consequently, if we select a certain brand of paper as the basis for our comparison, we will find that the same grade of another brand may produce a somewhat softer or harder print. To make the confusion even greater, the graded papers are labeled—besides the numerical index—with words indicating the

gradation. The soft paper is No. 1; normal, No. 2; medium, No. 3; hard, No. 4; and extra hard, No. 5.

My own experience can be used to show what I mean about confusion. When I arrived in the United States, I was acquainted with European papers, of course, and my negative technique was adjusted to making enlargements mainly on normal paper. I was very surprised to find that I could not obtain a crisp rendition on American normal papers with negatives that, according to my judgment, required a normal paper. Later, I found out the difference between American and European papers. I saw a box of European paper on the shelf of a camera store. The box of Agfa *soft* paper was labeled No. 2 for the American market. Agfa took this difference into account so that the expressive figure would match the rendition to which American photographers were accustomed.

Thus, the actual rendition of similarly graded papers varies with make; and, what is more complicating, differences may show up within the same brand, sort, and grade of paper bearing different emulsion numbers from one box of paper to the other. Gradation differences from one box of paper to the other are hardly noticeable, but sensitivity differences definitely are. Therefore, if you open a fresh box of paper, do not make your test strips on the remainder of the old box, unless your tests prove that the two boxes are identical in every relationship. These observations apply to variable contrast papers, as well.

The behavior of papers will also change with the age of the paper. Regardless of the uniformity of the emulsions, no one can really tell when a particular box came off the production line. Although the manufacturer guarantees the quality of the papers until a date printed on the box, this guarantee only implies that the paper will be usable until the date indicated. It does not assure perfectly uniform performance throughout the guaranteed life of the paper.

Outdated papers can be used with acceptable results after some re-evaluation concerning speed and gradation. Black-and-white papers are much less critical in this respect than are films. Color materials are even more affected by aging.

I have mentioned the point of outdated papers merely to point out one of the causes of nonuniformity within one type and brand of paper. We may assume uniform performance within the same brand and type; however, when we switch to another brand or type, we must anticipate differences. For instance, Kodabromide papers are about one-fourth grade softer than identically marked Velour Black.

Variable Contrast Papers

The situation is the same with variable contrast papers, though it may be somewhat complicated by the fact that DuPont or Kodak filters may be used interchangeably with American variable contrast papers. Rendition is changed somewhat when filters—accepted as equivalent—are interchanged with this or that brand of paper.

The behavior of variable contrast papers is due to the fact that their emulsion responds with a different contrast rendition when the color of the projected light is changed. The bluer the light, the more contrast is obtained; the yellower the light (up to a certain limit), the softer the rendition.

The filters can be placed either under the enlarger lens, or between the negative carrier and the condenser when a color drawer is built into the enlarger head.

Kodak filters are numbered from 1 to 4 with intermediate half-stop densities. So seven filters are available. The old DuPont set is numbered from 1 to 10, whereas the new sets are numbered from 0 to 4. In all sets the lower numbers represent the softer rendition. Either Kodak or DuPont papers used without a filter produce an approximately normal contrast rendition. Normal rendition is

Variable contrast filter placed under the lens.

achieved, also, when using the old DuPont No. 5 or No. 6, or the new No. 2, or the Kodak No. 1½ or No. 2 filter. Slight deviations, of course, have to be taken into account depending on the brand of paper.

The lowest contrast can be achieved with the old DuPont No. 1 filter, or the new No. 0 filter; highest contrast is rendered by the Kodak No. 4. A slightly higher contrast can be obtained by using a dark blue Kodak Wratten 47B filter. By no means, however, can the contrast of No. 5 conventional paper be rivaled by any variable contrast paper.

The contrast can be influenced by the dilution of the developer. Thus, if we use the stock solution of, say, Dektol developer in combination with the Kodak Wratten 47B filter, the contrast may approach that of Kodabromide No. 5 paper. On the other side of the scale, it is easier to obtain lower contrast on variable contrast paper than Kodabromide No. 1 paper will provide. The following table indicates the contrast rendition of various papers used with either Kodak or DuPont filters. As a standard, the contrast rendition of Kodabromide was selected.

Contrast Rendition

	No. 1 Soft ☐	No. 2 Normal ☐	No. 3 Medium ☐	No. 4 Hard ☐
American papers used with				
Kodak filters	#1	#2	#3	#4
		or no filter		
DuPont filters	#3	#5	#7	#10

See also in **Appendix.**

For the sake of simplicity I indicated only four filter numbers; intermediate filter grades would indicate intermediate contrast rendition.

Because the old DuPont and Kodak filters cut a certain part of the illumination, exposure times have to be increased when increasingly darker or more actinic filters are used. The following tables indicate the approximate ratios of exposure times used with Polycontrast paper with the medium contrast filter standardized as 1X.

DuPont Filters

New	#0			#1			#2	#3		#4	
Old	#1	#2	#3	#4	#5	No filter	#6	#7	#8	#9	#10
Polycontrast	1.4	1.3	1.3	1.3	1	0.7	1	1	1	1.5	2.4
Polycontrast Rapid	1.3	1.1	1.1	1	0.6	0.4	0.6	0.9	1	1.1	2.5
Varigam	1.3	1.1	1	1	0.7	0.4	0.7	0.9	1	1.2	2.5
Varilour	1	1	0.9	0.9	0.6	0.4	0.6	0.9	1	1.3	2.8

See also in **Appendix.**

The new DuPont filters provide uniform exposure times except the No. 4, which requires exactly double that of the others.

Besides using a separate filter for each contrast grade, you can obtain the same range of contrasts by using only two filters (the lowest and highest contrast filters) for various portions of time out of the total exposure time. Simmon Brothers, manufacturers of the

Kodak Filters

	#1	#1½	No filter	#2	#2½	#3	#3½	#4
Polycontrast	1	0.7	0.5	0.7	0.7	1	1.3	2
Polycontrast Rapid	1.3	0.9	0.6	0.9	0.9	1	1.3	2.6
Varigam	1	0.7	0.5	0.7	0.7	1	1.5	3.5
Varilour	0.9	0.7	0.5	0.7	0.7	1	1.3	3

See also in Appendix.

Omega Enlarger, introduced a variable contrast timer that works on the two filter system. You set the contrast dial to the required contrast marks. The exposure of the paper under the two filters is electrically timed. The total exposure time is set in on another dial on the timer.

The use of variable contrast papers provides local control of contrast. For instance, it is possible that for a low contrast or thin area of the projected image the highest contrast filter is used; then we switch to the appropriate filter for the rest of the projected area, covering the area that required additional contrast. (Actually, we start the exposure by using the highest contrast filter for the time required by the low contrast area, but over the entire projection area.) We can also burn in overly dense areas without the use of any filter, thus decreasing burning-in time.

Paper Surfaces

Besides the property of photographic papers that contrast can be controlled almost at will, another decision determines the choice of papers. A variety of paper surfaces exists from which to choose one compatible with the content or destination of the photograph.

Besides individual taste, various factors govern the choice of surface and, perhaps, the tone of the paper base (such as chamois, cream, or white). For portraits, one of the matte surfaces is usually

more desirable than a glossy one; for magazine or other reproduction purposes the glossy surface is preferred. On the counter of photo stores you may find sample books of each major paper manufacturer. You can select the surface that matches your need and taste from these books. There is also an indication of the contrast grades in which the paper is available.

In the processing of matte papers, one must take into account that the visible brilliance of the print is greater when it is wet and that after drying the print will darken. Those two phenomena are interconnected. Therefore, you must make lighter and somewhat more contrasty prints than might be indicated by your test strips. Experience will enable you to judge how much lighter and more contrasty a print must appear when wet in order to give the desired result when it is dry.

A similar phenomenon takes place in the processing of some glossy papers. During development the print does not show its full brilliance; the blacks appear gray, and there appears to be a slight

This print and the one on the opposite page are from the same negative printed with different variable contrast filters.

milky coating over the entire print. But after the print is trans-
ferred to the hypo, the milky appearance vanishes in a few seconds
and the print assumes its final appearance. The soft graded papers
of some manufacturers are particularly likely to do this.

The Developers

Although most photographic paper manufacturers recommend
their own developers, this does not mean that another brand of
developer cannot be used for a particular brand of paper. Paper
developers are based on the good old metol–hydroquinone formula
(in some developers the metol has been replaced by phenidone in
a ratio of about 10:1). All the developers available on the market
are standard developers. Standard means that they produce neither
very great nor very low contrast, but just normal.

The contrast effect of a developer can be regulated, however,
through dilution of the stock solution (if there is one). For ex-
ample, the recommended working solution for Dektol developer

is one part stock solution to two parts water. Undiluted, it gives high contrast prints; diluted with three or four parts water, it gives soft prints. A developer cannot, of course, be diluted beyond a certain limit.

In addition to the standard developers, there are those that produce a warmer tonal effect than others. There are also developer additives, such as benzotriazole, which will produce blue-black tones. These additives also prevent fog and increase contrast. Use them with outdated papers. Specific instructions for their use will be found on the package. These instructions usually tell you how many prints can be processed in that volume of solution, but it is safer to make your own experiments.

If someone wants more deviation from the regulation possibilities of the ready-made developers, here are developer formulas for that purpose.

Paper Developer Formulas

	Normal		Gradation Contrasty		Soft	
Metol	15	ounces	31 ounces	54	ounces	
Hydroquinone	62	ounces	124 ounces	—		
Sodium sulfite, desiccated	310	ounces	310 ounces	232	ounces	
Sodium carbonate, monohydrated	465	ounces	465 ounces	—		
Potassium carbonate	—		—	232	ounces	
Potassium bromide	7½	ounces	15 ounces	7½	ounces	
Water, not over 100° F.	32	ounces	32 ounces	32	ounces	

Add chemicals in the given order, stirring continuously. Sodium sulfite has to be added to the solution very slowly and in small amounts; if you add it too quickly, the metol might precipitate from the solution and would not redissolve.

The Other Solutions

The other solutions of the positive process—the short stop and the hypo—are the same as those used for processing negatives, except that they are diluted in a different ratio. Check the instructions on the bottle label.

Since the hypo gets exhausted after a certain number of prints are fixed, it is wise to check the exhaustion of the hypo with Hypo-check. When a few drops of Hypo-check are poured into a test tube containing hypo, and a milky substance is formed, it means that so much silver has accumulated in the hypo that the potassium iodide of the Hypo-check has compounded with the excess silver to form silver iodide. If this cloudiness disappears a few seconds after the tube is agitated, it means that the hypo is nearing the end of its life. If the cloudiness remains, the hypo must be discarded.

In any case, as hypo gets older, it takes longer to accomplish its work, and we cannot really be sure that fixing is completed. It is, therefore, a good idea to have a two hypo bath system. The first bath removes the greater part of the silver halide from the print; the second bath removes the remainder. Since the first bath does the most work, the second bath remains relatively fresh, and the first bath becomes saturated much earlier. When the first bath is exhausted, it should be discarded; the second bath is then used as the first, and a new batch is mixed for a second bath.

All chemicals and all secondary silver-hypo salts must be completely washed out of the emulsion if we wish either to tone the prints or intensify or reduce them. To make print washing faster and more sure, a hypo eliminator can be used. This is especially advisable when the temperature of wash water is below 60° F., and the solution of silver salts may take hours.

Insufficient fixing or washing will show up when areas of the print are toned, reduced, or intensified, in the form of dark spots. As mentioned in the previous chapter, this failure may show up as soon as the prints are dried, in the form of yellow stain.

The Final Steps

Although drying may seem to be a very simple process, matte spots may appear when the prints are processed for high gloss,

even if single weight prints are involved. To minimize this tendency, make sure that ferrotype plates are absolutely clean. There are products on the market for cleaning ferrotype plates and other shiny surfaces, such as the glass in the negative carrier and even the nonemulsion side of the negative. To ease the procedure, the prints can be immersed in a high gloss solution before being placed on the plate or drum. These preparations serve as wetting agents as well as print flatteners and may also produce an anti-static effect.

Now we have reached the final stage of print making, and we can mount the prints as described in the previous chapter, or place them in a folder or album. They may also be left loose for filing.

PICTURE PORTFOLIO

Civilization 1.

Civilization II.

Birds I.

Birds II.

Patterns I.

Patterns II.

Coliseum I.

Coliseum II.

Boats I.

Boats II.

Slice of Time I.

Slice of Time II.

Group Shot.

Closing in.

Sunday in the Park I.

Sunday in the Park II.

Village Rooftops.

Contre Jour.

Peace.

Modern Dance I.

Modern Dance II.

Speed I.

Speed II.

Circles I.

Circles II.

He is looking at you.

They are talking about you.

Hey...don't yell at me!

Hey . . . don't push me!

Patterns of Wood.

Patterns of Metal.

Pattern of Machines.

Machine made patterns.

PART III
COLOR PROCESSING

7

The Procedure in Principle

All color materials except the Kodachromes can be processed at home. Home processing kits are available for this purpose. If you follow the instructions exactly and you have some experience in black-and-white processing, you should have no trouble. I feel, however, that one must know how the procedure works in principle, to minimize the possibility of errors.

All color materials—reversal film, negative film, or positive material—contain three light sensitive layers. Each is sensitized to a different area of the spectrum. The top layer is sensitive to blue, the middle layer is sensitive to green and blue, and the bottom layer is sensitive to red and blue. To cut blue light rays reaching the second and third layers, a very thin yellow layer is coated between the first and second layers. This layer serves as yellow filter, and it is made of colloidal silver distributed in the gelatin of the layer. In this way the second and third layers are protected against blue radiation, and their blue sensitivity is not used.

According to color theory only three basic colors of the spectrum have to be mixed to get colorless (white) light again. These three fundamental colors of the spectrum, which when added to

each other in adequate proportion give white again, are blue, green, and red. If we can mix white from these three colors, it is obvious that we can mix any other colors if the proportions are changed. If we reverse the idea, any available color affects the three layers of the color film in the ratio of the mixture of those three fundamental colors from which that specific color came into existence. In this way the exposure in each individual layer follows exactly the amount of each fundamental color incorporated into the photographed color. So after appropriate black-and-white development each layer shows a distribution of silver, which necessarily follows the exposure exactly. In this way the complete negative image of the subject is split into three parts. Up to this point, the development of the color negative and reversal film is almost identical. You will realize soon why I said "almost." Actually, in producing a black-and-white silver image the two *are* identical. However, our final objective is to produce a color image—either negative or positive—and not a black-and-white image. Here, the two kinds of processing deviate from each other, but the basis is the same.

Producing visible colors in the three layers of the emulsion is achieved in an ingenious way. There are certain organic dyes of very complicated chemical construction. If we split their construction into two parts, they are not dyes any more, just compounds. If we put one part in the emulsion and the missing part in the developer, it is obvious that these dyes come into existence when the developer affects the emulsion. Actually, the developing agent itself is not the missing part; just the oxidation product of it, produced during the course of the development. Since this oxidation product comes into existence in those areas where the developer works (where exposure was made), necessarily, distribution of the developed dyes follows the exposure.

A special developing agent used in many of the older color developers is diethyl paraphenylene diamine and its close rela-

tives. Certain newer developing agents, such as 4-amino-N-ethyl-N-[β-methane-sulfonamidoethyl]-m-toluidine sesquisulfate monohydrate and 4-amino-3-methyl-N-ethyl-N-[β-hydroxyethyl]-aniline sulfate, are designed both to produce better color rendition and to have reduced toxicity. The oxidation products of the *regular* developing agents do not affect the other component of the dyes. If we first do a regular black-and-white development, only silver is produced in these areas. If we then expose the remaining silver halide to light, it becomes developable for the color developer, which, together with the silver, produces the needed dyes at those places not affected by the first development. This is the reversal procedure. If we do the color development at first, dyes are produced soon at those places where the latent image lies.

Since the blue sensitive layer contains the component of the yellow dye, the green contains the magenta, and the bottom layer, which is red sensitive, produces the cyan dye, it is obvious that if the first development is already a color development, these complementary colors come into being at those places where the latent image lies. Thus, a color negative image is produced. When the colors are produced by the second development, a color positive image is the result. This is the goal of the reversal procedure. In the negative and reversal procedure we no longer need the black silver image, only the color image. Therefore, we bleach out the metallic silver. Together with the bleaching of the developed silver, the colloid silver of the yellow filter layer is bleached so we get a clear dye image.

These are the rough outlines of the course of producing either a color negative or a color positive image. The diagrams in the color section will show how it works in practice; then you will fully understand the entire process. To complete the picture, however, one more piece of information is necessary; that is, how the various mixtures of colors come into being when you see a transparency or

color print. As I mentioned above, the exposure was made by the additive mixing of colors; that is, when we add the three fundamental colors in the form of light rays projected onto each other, we obtain white. Black is obtained when no light rays exist at all. Colors, however, can be mixed by the subtractive method. This means that when colorless light is projected through layers containing transparent dyes, each layer subtracts that color in the white light that is complementary to its own color. Therefore, if all three layers contain dyes, no light can go through and we obtain black. The dyes of the layers are: cyan (blue-green) in the bottom layer, magenta (blue-red) in the middle layer, and yellow (red-green) in the top layer. Now, refer to the diagram of reversal processing in the color section.

If only the bottom and middle layers contain the full amount of dyes to be developable, the cyan layer retains the yellow but the green and blue go through. In the middle layer, however, the magenta dye retains green and blue. If only one layer contains the dye, it appears in its own color. When the top layer is involved in producing color in connection with one of the other layers, the yellow dye retains the blue part of either the magenta or cyan light. Meanwhile, its own color perished when the blue was absorbed and only the red or green components of the previous color remain. We obtain pure colors only when the dyes are developed in the correct quantity. If in a layer less dye is developed owing to less exposure, the dyes of the other layers become dominant in the mixture. So we are able to get the intermediate colors and any variation of any color, such as orange, yellow-green, violet, gray, or pink.

You can get a clear view of how the mixing system works when you take a look at the color circle.

As you can see, the principles of reversal and negative–positive procedures are the same, but the latter is split into two separate

Color circle.

media. Consequently, because of this split, the results of the second part of the process can be influenced by filters. Hence, changes in the color of the available illumination—such as the difference between daylight and tungsten, or the differences *within* daylight illumination from hour to hour during the day—can be balanced out by the appropriate combination of filters. In the reversal procedure, however, different films are used for tungsten and daylight illumination. (We can also, of course, use conversion filters when making the exposure.) Slight differences in the illumination have to be balanced out through the use of color correction filters at the time of the exposure. The result, then, is final and unalterable. It is one of the great advantages of color negative film that it can be used under any illumination. Moreover, if an error is made in the selection of a printing filter, the process can be repeated until a desirable result is obtained.

Processing

The processing of color negative and reversal film does not differ too much from that of black-and-white film in the manner of execution. More solutions are used, more exact temperature control is required, and even greater care must be taken to avoid contamination of solutions, especially the color developer and bleach. In each home processing kit exact instructions are provided, and if the instructions are followed to the letter, failure is impossible. Pay attention to the temperature and to the proper turbulence of the wash water after the development stage, especially when Agfacolor negative film is processed.

In the case of color reversal material, the principle of processing is as follows:

The first development develops metallic silver in those areas where exposure affected the individual layers. Since color rendition depends upon the gradation achieved in each layer during development, it is not surprising that a half-degree temperature tolerance has to be maintained. Agitation and developing time must follow exactly the manufacturer's instructions, as well.

For the sake of proper color rendition, the gradation curves of all three layers must be parallel and a specific gamma (the trigonometric expression of the steepness of the gradation curve) has to be maintained. If the gamma of one layer is different from those of the other two, or if all three gammas are different, severe shifts in color rendition will occur. Great deviation from the parallel, however, happens mostly in outdated film. Deviation from the recommended developing method *in combination* with altered exposure times causes higher gamma values in all three layers, but not necessarily the same values. Some films, therefore, lend themselves to altered exposure time and pushing; others do not.

Although pushing does not offer such perfect color rendition that a painter would be happy seeing such color reproductions

taken from his paintings, it may not arouse the criticism of a spectator who is less color-conscious than a painter. So pushing may be permitted in emergency, or for special effects.

After first development, the stop bath takes care of immediate stopping of the further effect of the developer. The hardening bath prevents the extremely soft emulsion from being hurt during the following steps of the procedure. A few minutes' washing removes the chemicals from the emulsion, and the three layers have to be readied for the color development. Since an emulsion is ready for development if sufficient exposure was made, we have to do this exposure by a strong light source during a certain period of time, as recommended in the instruction sheet of the developing kit. This exposure cannot affect those parts of the emulsion where metallic silver is already found, but any other unaffected silver halide is transformed into developable "latent image" owing to the strong exposure. The second (color) development, therefore, affects all those areas that remained free of metallic silver after the first development. During this second development, besides metallic silver, dyes are also produced as a result of the chemical association of those two components that were previously separate in the layers and in the developer, *i.e.*, the oxidation product of the developer. Because the components in each layer are different, different dyes are produced in each layer.

At this stage, all the three layers are full of metallic silver, and in the appropriate places dyes are joined to the silver. After this second development, similar to the first, short stop and hardener are used for the same purposes as before. And similarly, all the chemicals must be washed out thoroughly from the emulsion before the bleaching procedure is done.

The bleach removes all the metallic silver from the emulsion, or, correctly speaking, transforms the metallic silver into a silver halide, which can be dissolved by the action of the fixer. Together

with the developed silver, the colloidal silver of the yellow filter layer, which is between the top and the second layer, is removed. In this way, after fixing, only the dye image, which is necessarily color positive, remains in the three layers. Besides the aforementioned solutions, some more solutions are used to stabilize the dye image, and to prevent fading as long as possible.

The processing of negative film is similar to that of the reversal film; the main difference is that a separate black-and-white negative development is not necessary. The dyes are produced during the first development, and this dye image is complementary to the colors of the object. So neither second development nor second exposure are called for in this case.

The development of the positive materials follows the same principle as the negative. As a result, the developed dye image of the positive is complementary to that of the negative, and in this way we regain the original colors of the subject.

When I said that this or that image is complementary to its counterpart, it was said for the sake of simplicity, but it is only approximately true. In order to get the best possible color rendition, some deviations have been introduced during the development of research of color chemistry. Kodacolor and Ektacolor negative films, for instance, have a strong orange cast that practically overlaps all other colors of the negative. The colors of the positive are still clear if the filtration is correct. This orange cast is consciously put into the emulsion during the manufacture, and it is called a *mask*.

It is not the objective of this book to examine why those deviations occur. I can tell you that there are good reasons for those deviations, but they lie in the territory of advanced photochemistry and photographic science.

8

Color Equipment

Whether color or black-and-white film is processed under amateur circumstances, the equipment is actually the same. The tank, the thermometer, the storage bottles, the darkroom graduate, the funnels are all our well-known tools. Among the specific requirements of color processing, however, some restrictions must be set.

First of all, the thermometer must be a very exact one, and half-degree readability is required. The reel of the developing tank must allow penetration of light during the second exposure; therefore, at least one of its two wheels must be made of white plastic material if we do not wish to remove the film for the second exposure. But even if you have such a translucent reel, I recommend removing the film and doing the second exposure with the film hanging free. In doing this, take care that water drops do not accumulate on the surface or on the back of the film, because they act like lenses and small pink or blue circles may show up in the transparency as a result of uneven illumination. Therefore, the back of the film—where it is most likely that drops will collect—must be wiped off gently. After the exposure is done (exact information is provided in the instruction sheets of the developing kits regarding light source, timing, and distance), the film must be reloaded onto

the reel. Since the wet color film is extremely easy to damage, greatest care has to be taken during this procedure. The only method by which we can reload the film is by starting from the inside, because wet film will not slip into the grooves, even if we try to do it when it is immersed in water. A 20-exposure roll of 35mm film may slip in without too much difficulty, but a 36-exposure roll or a 2¼″ × 2¼″ roll would be, at best, difficult.

It is also advantageous to remove the roll from the tank for the second exposure, because this affords an opportunity to wash the tank and reel. *It is absolutely necessary to do this.* It must be done perfectly, since color processing is much more critical in this respect than is black-and-white processing. The reel has to be taken apart (most of the currently produced reels are constructed so that this is possible) and washed thoroughly under a jet of water. The tank itself must also be washed. Then we can reload the film. After the entire process has been completed, the tank and reel must be washed again. The bleach and color developer are particularly bad enemies, and traces of bleach remaining in the reel for the next processing, or traces of color developer left in the tank prior to the next step—the bleaching—result in small pink or magenta spots on the film.

Since the exact maintenance of the suggested temperature limits of the wash water is required, a mixing faucet is a necessity. In the use of such a device, beware of dropping or increasing pressure on either the hot or cold water lines caused by the turning on of a faucet somewhere else in the system.

For sheet film processing, either regular amateur tanks or special color developing outfits can be purchased. The latter cost about $100 and contain five, six, or seven insert tanks surrounded by a water jacket to maintain a steady temperature control. They can be used for either the processing of sheet films or the color positive materials of the negative–positive procedure.

Negative–positive processing can be done, of course, in regular developing trays, and because the trays are inexpensive, separate trays can be used for each solution. The short stop and hypo trays that we use for black-and-white work can be used for the same solutions in color work also, but the developer tray definitely cannot be used for color developer. So some additional trays must be purchased for this purpose.

If more than one paper is developed at the same time, greatest care has to be taken to avoid scratching the soft emulsion.

The temperature of the color developer has to be measured after the developer has been poured into the tray. If the room temperature differs too much from the required temperature of the developer, a water jacket is required to maintain a constant temperature during the entire developing process. The water jacket can be a larger tray containing water at the required temperature. The developing tray can then be immersed in the larger tray.

To provide the best temperature control, you should use stainless steel or enamel trays for development.

To bring the processing time of a color print down to 7½ minutes, Kodak introduced the Kodak Rapid Processor. This basically simple device takes advantage of that well-known fact that chemical reactions occur faster at higher temperatures and under more vigorous agitation. So the solutions are heated to 100° F. and the drum rotates at a speed of 200 linear feet in one minute (actually 100 rpm). Because the price is under $300, it is within the reach of an amateur photographer.

Enlarging

The apparatus for color enlargements is basically the same as for black-and-white work. Only one more tool is essential for color work, that is, application of printing filters. This is achieved by the so-called "color drawer," which is located between the con-

denser lens and the negative carrier. The color drawer accepts a filter pack, which is arranged according to the necessity of correction. If we were to make color prints from any negative without filters, correct color rendition could not be achieved, because of the different renditions of the color negative and the color positive materials owing to the specific properties of each material. Because these renditions are shifted both in the negative and in the positive material toward a definite color, the application of a filter combination that provides a complementary color for the result of the two way shift achieves neutralization. The neutralization of these shiftings means restoring correct color rendition in the final product of the negative–positive procedure. Besides the individual properties of both the negative and positive material, the color of the illumination at the time of the exposure causes shifted color rendition, too, and filtration also corrects this shift.

Filtering

Filter sets are available containing a series of filters of different densities in each of the three fundamental colors—yellow, magenta, and cyan. The densities are marked in increasing numbers from 5 or 10 to 99 at intervals of 10.

When we make the first proof print, we have to use the basic filter combination, which is printed on the box of paper in the form of a six-digit combination, *e.g.*, 35 15 00. According to the international standards that determine the sequence of colors in the filter pack formula, this means density values of 35 yellow, 15 magenta, and no cyan. To make a 35 yellow filter, we should use the No. 30 plus the No. 5 or the No. 10, No. 20, and No. 5 yellow filters. It never happens that three colors are used in the filter pack, since one of the filters would neutralize its equivalent density in the color composition of the other two.

In practice, filtering is done after you have evaluated the proof

Filter placed into the color drawer.

print. If the print shows a slight cyan discoloration, that means that in the bottom layer (which contains the cyan color) more dye has been developed than necessary. This is because of the excessive red light component of the exposure, the bottom layer being sensitive to red. To hold back the excess red light, its complementary color, the cyan (see color circle) should be used as a filter. How strong this filter must be depends upon the strength of the discoloration and after some experience we can estimate it approximately.

If we estimate, for instance, that a No. 10 cyan filter is necessary to balance excess red illumination, which causes the cyan discoloration, this filter should be added to the basic filter pack (the

35 15 00). The new filter pack would then become 35 15 10. But since, according to the rule, we do not use three colors at the same time, we eliminate one of the filters by subtracting the lowest filter value from all three in the new pack. Thus, 35 15 10 becomes 25 05 00. If we estimated that a No. 25 cyan filter were necessary, the filter pack would become 35 15 25. When reduced by the lowest factor, the final filter pack would be 20 00 10.

The following table shows what kind of filters must be used for various discolorations of the proof print:

Discoloration	Filter
cyan	cyan
magenta	magenta
yellow	yellow
red	yellow plus magenta
green	yellow plus cyan
blue	magenta plus cyan

As you know, we can mix any kind of color from the three available colors of the filter set. And if you take a look at the color circle, you will find out that the combination of the two adjacent colors produces exactly the wanted color. Now another example. Suppose that the discoloration of the proof print is yellowish-green and we estimate that a combination of No. 30 yellow and No. 15 cyan must be added to the basic filter pack. So the new filter pack would be: 65 15 15, which is equivalent to 50 00 00.

As you can see only simple arithmetic is needed to determine the filters to be used in the filter pack. This determination follows our evaluation of the discoloration of the proof print. But this determination is not so easy in practice as theory would have it seem. In practice, there are invisible and therefore unpredictable components that influence the final result. Among these are the state of the paper and developer because of aging and exhaustion. Owing to these unforeseeable influences, you cannot use the same

filter combination today for a print made from the same box of paper, same developer, and same negative you used a week ago. The new proof print may be similar to the one you produced a week prior, but it is possible that deviation will occur and you will have to start the whole trial-and-error procedure from the beginning, using the basic filter pack.

Mosaic Filters

Because color printing is such a tricky business, means have been introduced to make it simpler. These means are the so-called "mosaic filters." Three of them are necessary to determine the approximate filter combinations. Each filter is a combination of two filter colors in varying densities. For instance, the yellow-magenta mosaic filter (the yellow-cyan and the magenta-cyan are the other two) contains combinations from 00 00 00 to 99 99 00 in equally increasing grades of densities such as 10, 20, or 25. A yellow-magenta mosaic filter with 20 increasing densities looks as follows:

00 00 00	20 00 00	40 00 00	60 00 00	80 00 00	99 00 00
00 20 00	20 20 00	40 20 00	60 20 00	80 20 00	99 20 00
00 40 00	20 40 00	40 40 00	60 40 00	80 40 00	99 40 00
00 60 00	20 60 00	40 60 00	60 60 00	80 60 00	99 60 00
00 80 00	20 80 00	40 80 00	60 80 00	80 80 00	99 80 00
00 99 00	20 99 00	40 99 00	60 99 00	80 99 00	99 99 00

The other two mosaic filters are constructed in the same way, and the figures, of course, indicate the densities of the colors included.

When used, the appropriate mosaic filter is placed onto the paper, and the exposure is made through it. The appropriate filter shows up after the proof print is made. If the proof print has a discoloration of red, reddish-yellow, or reddish-magenta, then the yellow-magenta combination must be used. If the discoloration is green, green-yellow, or greenish-cyan, the yellow-cyan filter has to

be used. If the discoloration shows up as a blue, bluish-cyan, or bluish-magenta cast, then the magenta-cyan mosaic filter must be used. The basic filter pack must remain of course in the color drawer of the enlarger or in the filter holder when the test exposure is made through the mosaic filter.

Though the use of mosaic filters seems to be a reliable method of determining the appropriate filter combination, the results are in reality only approximate. Why? Because it may be that the square of mosaic that would be the correct one is located over an area of the print on which it is difficult to judge whether color rendition is good or not, owing to the lack of comparison.

If we suppose that the correct square is located over a red dress, for instance, we might not be able to remember exactly what kind of red the dress actually was in nature. It may be that the red in nature was warmer than we supposed. If we add to the basic filter pack the filter predicated by our faulty recollection of the color, the print will be rendered colder throughout, and faces will have a blue or green tinge.

Determining Exposure Time

The situation is complicated by the fact that the correct exposure time for each square, owing to their different densities, is different, so we do not know if the supposedly correct square was actually correctly exposed or not. Correct exposure is essential in combination with the correct filter combination. Therefore, a good deal of guess work is still necessary with the use of mosaic filters, and we cannot completely avoid the trial-and-error method.

The basis for a correct exposure time can be determined in a manner similar to the test strip method we used in black-and-white enlarging. Since the speed of color paper is about equal to that of black-and-white normal papers, we make our test strip on black-and-white paper first. When making this test strip, we have to

remove the basic filter pack from the enlarger. The exposure time thus derived is valid only without filters and the exposure time for the color proof, which follows, must take into account the light absorbing effect of the filters. Calculating this effect is simple. Yellow filters of 10–50 density value increase exposure time by about 10 per cent, and 60–99 density about 20 per cent. The No. 10 magenta filter increases exposure time by 20 per cent and other magenta filters require a 15 per cent increase for each additional 20 density value units. The No. 10 cyan filter takes a 30 per cent increase with 10 per cent for each additional 10 density value units up to the No. 60 and 20 per cent of the basic exposure time thereafter. In the following table, you see how it looks in tabular form.

When the basic filter pack is put back in the color drawer of the enlarger, the increased exposure time should be calculated when we make the proof print. In case of a pack of 35 15 00, the new exposure time will be about 35 per cent longer (10 per cent for the No. 35 yellow and about 25 per cent for the No. 15 magenta) than it was before, when we made the black-and-white test

Filter Factors of Printing Filters

Filter No.	10	20	30	40	50	60	70	80	90	99
Yellow (%)	10	10	10	10	10	20	20	20	20	20
Magenta (%)	20	27	35	42	50	57	65	72	80	87
Cyan (%)	30	40	50	60	70	80	100	120	140	160

See also in Appendix.

strip. After the proof is made and we determine which mosaic filter must be used for the forthcoming test, another exposure time must be used depending upon which mosaic filter is used. So the previous exposure time must be increased by about 5 per cent for the yellow-magenta filter, about 75 per cent for the yellow-cyan filter, and about 100 per cent for the magenta-cyan mosaic filter. It is

obvious that these filter factors for the mosaic filters cannot be correct for each square of the filter, because of the different densities, but they give an average figure. After the appropriate square on the print is selected and the filter pack is put together according to the markings of that square in combination with the basic pack, the actual exposure time must be determined according to the filter factors of the filters actually used in the pack. Since the proper color rendition shows up only after the entire process is completed and the print is dry, we cannot make a critical judgment earlier. We can, however, make an approximate judgment by holding the wet print against a strong light source.

After much trial-and-error we finally achieve a filter combination that properly renders the colors. This filter combination is effective for all those negatives on the same roll that were subjected to the same exposure under the same light conditions.

If we deduct the filter numbers of the basic pack from the working pack, we obtain the specific combination for that particular roll of film. This only works, of course, if those frames that were exposed under average daylight conditions (5000–6000 K.) were taken into account.

For instance, if the working pack is 00 20 55 and the recommendation of the paper manufacturer was 35 15 00, the result would be −35 05 55. Because minus filter values do not exist, we have to add 35 to all three factors. The result is 00 40 90. This is the guide number for that roll of negatives (and for all those negatives of the same emulsion number developed under the same conditions). If you switch over to another box of paper, just add the guide number of the negative to the recommended filter combination of the paper to get an approximately correct working combination for the same negative. As I explained before, this combination is not always correct because of chemical changes in the paper emulsion and the degree of exhaustion of the developer

during the elapsing of time. But it is a very valuable base for further manipulations. So if we switch over to a box of paper the filter recommendation of which is 10 30 00, and we add this to the previously determined 00 40 90, the result is 10 70 90. After the deduction of the superfluous third filter the remainder is 00 60 80. This is the starting filter combination for that box of paper and for that emulsion number of negatives. So the proof print or the mosaic print can be made with this filter pack. In this filter pack (correctly speaking, in the combination determined for the negative) there is already incorporated the correction necessary to balance the illumination of our enlarger. This depends upon the bulb used, the color of the glass of the condenser lenses, and even on whether a glassless or glass negative carrier is used. The only changing component of this system is the aging of the bulb. So you may find that the more you use the bulb, the more cyan filter or less yellow and magenta filtration has to be used for the same negative than before, even if you use fresh paper and fresh developer. Another changing component that must be taken into account, aside from the enlarger's illumination system, is the fluctuation of the voltage of the electric current. Because this fluctuation may cause severe shifts in the color rendition, voltage regulation is necessary in critical color work.

Another sort of positive print making is the reversal procedure, which is especially popular here in the United States. This process works from color transparencies, instead of color negatives, and the printing material itself is obviously also reversal. Owing to the reversal procedure the filtration is done by complementary color filters. In other words, if a yellow cast appears on the proof print, an appropriate density of blue or cyan filter must be used for correction.

Because color materials are sensitive to each color, a special dark brown safelight filter should be used during the processing, but

with greatest care. The light must not strike the paper at all until three-fourths of the developing time has elapsed. Occasionally, and only for a few seconds afterwards, can we examine the course of the development. The situation is similar to the development of panchromatic film by inspection under the dark green safelight. At any rate, there is no need for inspection because the development is done by time and temperature, so the safelight serves only as a pilot light in the darkroom.

There are some enlargers for which no separate filters are required, because filters are built into the enlarger head. Turning three dials obtains the required filter combination. Intermediate values of densities can be set, because the setting of the three fundamental filters is done continuously, not step by step.

Sunset.

Handicraft.

Play of Water.

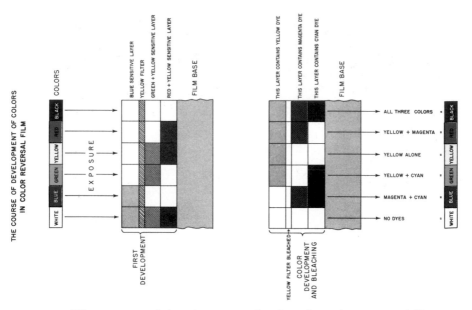

The course of development of colors in color reversal film.

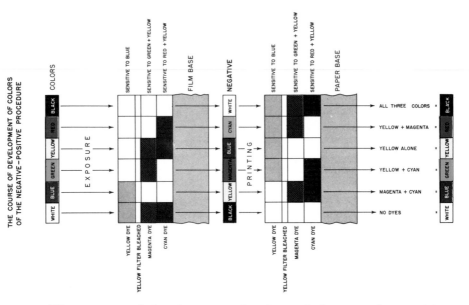

The course of development of colors of the negative–positive procedure.

9

Color Processing Materials

These materials can be divided into two large groups: the reversal materials, which produce transparencies ready for viewing, and the negative–positive materials, which produce a negative in the primary stage, not suitable for viewing. An intermediate group can be defined, however; the reversal positive materials, which are available for the production of prints, by the reversal method, from transparencies.

All the major film manufacturers of the world produce reversal materials, and through the roughly four decades of modern color photography's history, these materials have improved to the point that the ultimate in color reproduction has been attained. At the same time, the speed of these materials has increased to the point that they rival the fastest black-and-white films. In early 1957 the fastest color film was rated at ASA 32. By 1967, GAF had brought out a reversal film of ASA 500.

All color reversal films are produced in daylight and tungsten types, though not in all speeds.

Color Balance

Color temperature is the numerical expression of the color of the illumination in the Kelvin grades. The color temperature of daylight, for instance, is 5000–6000° K.; photoflood lamps provide a 3200–3400° K. illumination; clear glass flashbulbs provide between 3400–3800° K.; and the color temperature of speedlight is about the same as that of daylight. Daylight films are sensitized for 5000–6000° K., tungsten films for 3200–3400° K., and Type F film is balanced for 3400–3800° K. illumination.

Grain and Resolution

Kodachrome film ASA 10 was first introduced into this country in the early thirties. Among modern color reversal films, the color brilliance, resolution, and grainlessness of it and its successors, Kodachrome II and Kodachrome-X, are still unmatched. Because of their complicated developing process (controlled diffusion of color developers), they can be processed only in large plants and not in the home. The other Eastman Kodak color films, as well as the other brands of color films available in this country, can be processed at home.

As we know from the features of black-and-white photography, graininess increases and resolution decreases as the speed of the film increases. This rule is valid for color films also, but not in so conspicuous a manner as for black-and-white films. This is because of the lack of silver grains. The holes between the silver grains cause the illusion of graininess in the positive black-and-white print when the distribution of grains shows up with a definite density. Since the construction of a color image differs from that of a black-and-white one (color is distributed into three layers), less opportunity is afforded to produce the illusion of grain.

Although high-speed color films do not have the resolution of black-and-white films of the same speed, it is not necessarily a rule

that color films cannot deliver as sharp an image as black-and-white films. I once saw an Agfacolor CN 14 35mm color negative blown up to 2′ × 3′—it was needle sharp and with no grain visible.

One way in which unsharpness may be introduced into your print is if your enlarger lens is not color corrected. This means that it will not focus the rays of one color on the same plane as the rest of the components of the color image. To test this, take a photograph of an airmail envelope. Place the resulting transparency in the glass negative carrier and with the lens wide open, focus on either the red or the blue. If you find that the other color can be refocused, and that when you do so, the first color goes out of focus, then your lens is obviously not color corrected.

Setting the highest standards of sharpness is of the utmost importance where 35mm films are involved, but becomes less important as the format becomes larger. Perfect color correction of the enlarger lens is required, however, by all formats.

Color Rendition

As a general statement about the rendition of different color reversal films, the Kodachromes are well known for brilliant, but somewhat contrasty rendition. Their European counterpart, Agfacolor reversal film (they are counterparts in the sense that both appeared on the market at about the same time and had about the same speed at the beginning), renders softer and somewhat more pastel colors.

Agfacolor can be processed at home (as can all other color films except the Kodachromes), but this film is very critical in the exactness of the washing time, since the post-developing effect of the first developer during the early part of the washing time is calculated into the entire development period.

Ektachrome-X ASA 64, Dynachrome 64, and High-Speed Ektachrome (the daylight type is rated at ASA 160; the tungsten type

is rated at ASA 125) are well-known for their rendition, which is slightly on the warm side. The lower-speed Anscochromes render colors somewhat cooler. Anscochrome 500, however, is also on the warm side and has remarkable contrast.

Printing Materials

Although they are printing materials, Ansco Printon and Eastman Kodak Ektachrome Type R paper belong to the reversal group. Printon is made of a celluloid base to strengthen the appearance of the colors, which is obviously less strong in an opaque base than in a transparency. Both materials can be processed at home, and any transparency can be enlarged.

In this respect, the negative–positive procedure is much more critical, because only the paper designed for a particular negative material gives best results. For instance, for Kodacolor and Ektacolor, only Ektacolor and Ektachrome Type C paper may be used.

Black-and-white enlargements can be made from color negatives. Any conventional or variable contrast paper can be used for the two Agfa films, but only Kodak Panalure, which compensates for the orange masking, can be used with the Kodak films.

Color Negative Materials

Kodacolor-X has an exposure index of 64 for both daylight and tungsten and is available in 35mm and roll film sizes. Ektacolor comes in two forms: Type L (long exposure), available in sheet film only, has an exposure index of ASA 64 tungsten; and Type S (short exposure), which has an exposure index of ASA 100 daylight, is available in 35mm size and larger. Agfacolor CN 14 is available only in 35mm form and its speed is ASA 20 daylight and ASA 16 tungsten. Agfacolor CN 17 has speeds of ASA 40 daylight and ASA 32 tungsten, and is available in sizes from 35mm to 8" × 10" sheet film. FR also supplies a complete color negative kit including film, paper, chemicals, and filters.

All color negative materials can be used under either daylight or artificial light conditions. Filtration, which takes place during enlargement, takes care of the variations in light color temperature. Avoid using these films under mixed light conditions because one filter combination cannot take care of both light sources when they occur in the same negative. For experimental and special effects, photographs with mixed illumination can be used, and by selecting the proper filter we can regulate the color of the different areas, but only in inseparable connection with each other.

Chemicals

Because a color developing kit contains a lot of different chemicals, organized work is necessary to save time when we dilute them. We can dilute two or more chemicals at the same time if we keep enough containers or darkroom graduates ready for this purpose. Since the developer is composed of several chemicals, and since one cannot be diluted until the other is completely dissolved, the developer takes the longest time to prepare. During this time, however, we can prepare the short stop, hardener, and perhaps the bleach. Be sure not to confuse one container for another and contaminate the materials. Several of these solutions are colorless and may easily be confused. Also, do not mix stirring rods because of the possibility of contamination.

After each solution is mixed, pour it immediately into its marked storage bottle, and clean the container in which it was mixed, in order to avoid contaminating the next solution that will be mixed in that container. Always use the same graduate for the two developers, and do not mix anything other than developer in it.

Because color developer does its best work a certain period of time after it is mixed, prepare the solutions on the day before the one on which you intend to use them. Although the instruction sheet may warn you that the developer should not be used beyond

two weeks after it was mixed (regardless of the number of rolls developed), it has been my experience that this period may be extended for a week or two without harm to the films developed in it, if the solution is stored in completely filled up polyethylene bottles.

Many people believe that the developer can be stored indefinitely if it is placed in a refrigerator. Although it is true that the cold will preserve the chemicals, it also changes the chemical composition of the solutions due to the crystallization of certain chemicals. These chemicals do not redissolve when the solution is warmed back to working temperature. So do not put your solutions in "cold storage"; leave them in the darkroom or some other dark and relatively cool place.

The suggested keeping time of the hardener is one week. Because this solution can be replaced so easily, there is no reason to keep it longer than the recommended time. I prefer to play it safe and mix a fresh, 3% solution of chrome alum. One can purchase, for a dollar, enough of this chemical to last a lifetime (that is, an amateur photographer's lifetime, which may be longer than a professional's).

APPENDIX I

Useful Data and Tables

1. ASA-DIN conversion table

ASA	10 DIN	ASA	10 DIN
8	10	250	25
10	11	320	26
12	12	400	27
16	13	500	28
20	14	640	29
25	15	800	30
32	16	1000	31
40	17	1300	32
50	18	1600	33
64	19	2000	34
80	20	2600	35
100	21	3200	36
125	22	4000	37
160	23	5200	38
200	24	6400	39
		8000	40

Note: Doubling the ASA number is equivalent to three numbers higher on the DIN scale and to doubling the sensitivity of the film.

151

2. Liquid measures

Quarts	Ounces	Milliliters
2	64	1900
1	32	950
½	16	475
¼	8	238
	4	120
	2	60
	1	30
	½	15
	¼	7½

3. Weight conversion table

Grams	Grains	Ounces	Grains	Grams (Approx.)
1	15½	¼	110	7
2	31	½	219	14½
3	46½	¾	329	22
4	62	1	437½	29
5	77½			
6	93			
7	108½			
8	124			
9	139½			
10	155			
25	¾ ounce and 62 grains			
50	1¾ ounces			
100	3½ ounces			

4. Inch-centimeter conversion table

Inches	Centimeters	Centimeters	Inches	Inches (Approx.)
1	2.54	1	0.394	⅜
2	5.08	2	0.787	⅝
3	7.62	2	0.787	¾
4	10.16	3	1.181	1³⁄₁₆
5	12.70	4	1.575	1⁹⁄₁₆
6	15.224	5	1.969	1¹⁵⁄₁₆
7	17.78	6	2.362	2⁵⁄₁₆
8	20.32	7	2.756	2¾
9	22.86	8	3.150	3⅛
12	30.50	9	3.543	3½
36	91.50			

5. Enlarging exposure times related to previous magnifications

1	1.5	2	2.5	3	4	5	6	8	10
1	1.5	2.25	3	4	6	9	12	20	30
0.7	1	1.5	2	2.75	4	6	8	12	20
0.5	0.75	1	1.25	1.75	2.75	4	5.5	9	13
0.33	0.5	0.75	1	1.25	2	3	4	7	10
0.25	0.33	0.5	0.75	1	1.5	2.25	3	5	7.5
0.16	0.25	0.33	0.5	0.7	1	1.5	2	3.5	5
0.11	0.16	0.25	0.33	0.5	0.7	1	1.3	2.25	3.25
0.08	0.12	0.2	0.25	0.33	0.5	0.75	1	1.75	2.5
0.05	0.08	0.11	0.16	0.2	0.33	0.5	0.6	1	1.5
0.03	0.05	0.08	0.1	0.15	0.2	0.33	0.6	0.7	1

Note: Find the number 1 in the vertical column of the magnification you were using. Then multiply the previous exposure time by the number that you find in the same horizontal line under the rate of the new magnification.

6. Approximate ratios of enlarging exposure times for different density filters for variable contrast papers.

New	#0			#1			#2	#3		#4	
Old	#1	#2	#3	#4	#5	No filter	#6	#7	#8	#9	#10
Polycontrast	1.4	1.3	1.3	1.3	1	0.7	1	1	1	1.5	2.4
Polycontrast Rapid	1.3	1.1	1.1	1	0.6	0.4	0.6	0.9	1	1.1	2.5
Varigam	1.3	1.1	1	1	0.7	0.4	0.7	0.9	1	1.2	2.5
Varilour	1	1	0.9	0.9	0.6	0.4	0.6	0.9	1	1.3	2.8

	#1	#1½	No filter	#2	#2½	#3	#3½	#4
Polycontrast	1	0.7	0.5	0.7	0.7	1	1.3	2
Polycontrast Rapid	1.3	0.9	0.6	0.9	0.9	1	1.3	2.6
Varigam	1	0.7	0.5	0.7	0.7	1	1.5	3.5
Varilour	0.9	0.7	0.5	0.7	0.7	1	1.3	3

7. Contrast rendition of variable contrast papers related to Kodabromide grades

	No. 1 Soft ☐	No. 2 Normal ☐	No. 3 Medium ☐	No. 4 Hard ☐
American papers used with				
Kodak filters	#1	#2	#3	#4
		or no filter		
DuPont filters	#3	#5	#7	#10

8. Filter factors of color printing filters

Filter No.	10	20	30	40	50	60	70	80	90	99
Yellow (%)	10	10	10	10	10	20	20	20	20	20
Magenta (%)	20	27	35	42	50	57	65	72	80	87
Cyan (%)	30	40	50	60	70	80	100	120	140	160

APPENDIX II

Equipment and Material Guide

For Negative Processing

Tanks:

Adjustable from 35mm—2¼" × 3¼": Ansco Anscomatic, Cormac Unitank, FR, Yankee Speed-O-Matic.

Nonadjustable: Agfa Rondinax 35 or 60; Kodacraft, Nikor.

Self-loading: Anscomatic, Yankee Speed-O-Matic, Rondinax, Eastman Kodak Dayload.

Apron-type: Kodacraft.

Stainless steel: Nikor.

Sheet film tanks: Ace Hardrubber, Cesco-lite plastic, Eastman Kodak Hardrubber, FR Adjustable, Nikor stainless steel, Yankee Utility, and Agitank.

Thermometers:

Dial thermometers: Eastman Kodak, Pako, and Weston.

Glass thermometers: Cheney, FR, Testrite, and Weksler.

Plastic funnels: Bowen, Yankee.

Bottles, polyethylene: Clayton, from 8 ounces to 5 gallons.

Darkroom graduates: Bel-Art, Casco, Leedal, Yankee.

Stirring rods: Eastman Kodak, or any dial or stirring-rod thermometer can be used.

Developers: Agfa Atomal, Rodinal; GAF Finex L, Normadol, Permadol, Isodol; Clayton P 60; Cormac Unibath CC-1 and CC-2; DuPont 16-D; Baumann Acufine; Edwal Super 20, Minicol, FG-7; FR X 22, X 44, X 33C, X 100, X 500; Ilford Microphen; Kodak DK 60a, D-76, Microdol-X; Kerofine 1500; May and Baker Promicrol; Plymouth Ethol UFG, Ethol TEC; Neofin Blue and Red.

Short stops: GAF, Clayton, Eastman Kodak, Edwal, FR.

Fixers: Albert, Clayton, DuPont, Eastman Kodak, Edwal, FR, Heico, Ilford.

Hypo eliminators: Clayton, Eastman Kodak, Edwal, FR, Heico.

Wetting agents: Best BPI 40, Kodak Photo-flo, FR, Pako.

Drying agents: Cormac Unidri, Yankee Instant Film Dryer.

Intensifiers: GAF Copper Int., Kodak Chromium Int., Victor Int.

For Positive Processing

Enlargers:

Ultraminiature: Minox 8–16mm, Minolta 9.5–35mm, Testrite 8mm–2¼" × 2¼", Kindermann "Amato."

35mm: Durst "Micromat," automatic, with color drawer, "Reporter," "40"; Federal "135"; Kindermann; Leitz Valoy, Focomat; Meopta Proximus, Axomat, Opemus; Primos Testreflex, Junior 35 and Professional 35, both autofocus; Simmon Omega A 2.

2¼" × 2¼"–35mm: Durst 606; Meopta Standard Opemus and Opemus II; Primos 2¼" × 2¼" Testreflex and 2¼" × 2¼" Autofocus; Simmon Chromega B-10 and B-9 (autofocus); Bogen Color 66; Kindermann Amatosix-Automat No. 1665.

2¼" × 3¼"–35mm: Beseler 23C; Burke & James Solarmatic, and Solar Model 120; Durst 609; Federal Models 240, 290, and 311; Leitz Focomat IIC; Meopta Magnifax; Primos Autofocus; Simmon Omega B-8, Automega B-7; Testrite Junior No. 2-Deluxe; Merit III, Model E; Kindermann Amatalux-Automat.

Up to 4" × 5": Beseler has several models; Burke & James Solar 450, Solarmatic; Durst Laborator 54; Federal Model 450; Simmon Omega D-2, Automega D-3, Chromega D-4; Testrite 100DC.

Enlarging aids: Willo: Dodgette set and Visible dodger; Bausch & Lomb: Focusing magnifier; Accura: Focusing Aid! Staticmaster antistatic brush), Blower brush.

Timers: GraLab Luminous and Universal Timers; FR Automatic Exposure Timer; Time-O-Lite M-59 (manual control), P-59 (manual and footswitch control); Rhodes Mark-Time.

Safelights: Brumberger 5" × 7" De Luxe; Eastman Kodak; Yankee; Kindermann.

Proof strip printers: Burke & James, HPI, Minoplex.

Contact printers: Airequipt, Brumberger, Burke & James.

Easels: Accura 4-way; Airequipt 4-way; Ganz Speed-Ez-Els; Octo Borderless; Saunders Bord-R-Less; Adjustable easels: Airequipt, Arkay, Durst, Premier, Saunders, Simmon Omega, Beseler, Leitz, Votar, Bogen.

Developing trays: Ace Hardrubber, Cesco-Lite Plastic, Delaware Plastic, Fisher Stainless Steel, FR Plastic, Grafic Stainless Steel, Enduro Stainless Steel, Yankee Plastic, Kindermann Plastic.

Print tongs: Stainless Steel: Carr, Cesco, Kent, Kindermann. Plastic: FR, Yankee.
Bamboo: Voss.

Print washers: Arkay, Burke & James, Richard, Kindermann, AAMEL. Lenz, DeHypo Turbulator, Kodak Tray-Syphon.

Print rollers: Eastman Kodak, Premier, Testrite.

Print dryers Flat: Arkay, Burke & James, Premier, Star-line. Rotary: Lott, Premier, Paco.

Print trimmers: Bradley, Burke & James, Chandler, Premier, Kindermann.

Toners: Eastman Kodak, FR, Atkinson.

Dry mounting presses: Seal Junior, Standard, Jumbo.
High gloss preparations: Albert, Braun, Merix, Pako.
Print flattening solutions: Albert, GAF, Atkinson, Braun, BPI 20, Eastman Kodak, Pako, Upson.

For Color Processing
Processing tanks with water jacket: Arkay, Carr, Copymation, Grafic, Fisher, Leedal.
Water temperature controls: Bar-Ray, Bernalen, OPW-Jordan, Powers, Simix.
Filter kit: GAF, Agfa, Kodak.

The above products are moderately priced and should fit into the budgets of most amateur and average professional photographers. There is equipment, however, that costs more than a Rolls Royce. Such products are, of course, not listed here.

Index

Additive mixing of colors, 128
Agitation, 16, 24
Autofocus enlarger, 65–66

Bleaching, 127, 131–132, 134
Burning-in, 70–71

Color circle, 129
Color enlarging, 135–136
 exposure time, 141 142
Color negative materials, 148–149
Color printing materials, 148
Color processing, 126–127, 130–132,
 149–150
Color reversal printing, 143–144
Color temperature, 146
Color transparency materials, 147–148
Condenser lens, 61–62
Contact printing, 58
Contrast, 12, 13, 14, 43, 53–55, 85
Convergent lines, correction of, 64

Developers, 36–46, 87–88
 handling of, 16
Developing tanks, 20–23
 loading tank, 20–21
 with sheet film, 24–26
Dodging, 70–71
Drying, 76–77

Enlarging, 59–73

Film
 high-speed, 15
 medium speed, 14–15
 slow speed, 14
 ultra-high-speed, 16
 washing and drying, 28–30, 49
Filter pack, 136–138
Filters (variable contrast), 83–85
Fixing, see Hypo

Glossy prints, 76–77, 89–90
Grain, 9–16, 146–147

Hypo, 17–18, 46–48
 check, 89
 eliminator, 47–48

Intensification, 49–51

Latent image, 7–8
 development of, 8–12

Masks, 66–67
Matte prints, 76–77
Mosaic filters, 139–140
Mounting, 77–78

Negative carrier, 62, 65

Papers, photographic, 79–87
 contact, 79–80
 graded, 80–82
 projection,79
 variable contrast, 80, 83–85
pH index, 10, 11, 40
Pushing, 131

Reduction, 49–51, 57
Resolution, 14, 146
Reticulation, 17

Safelights, 26, 71–73
Solutions
 mixing and storing, 31–35

Stop bath, 17, 46

Tanks, 20–23, 24–26, 133–134
Test strips, 68–69
Thermometers, 23–24
Timer, 69–70
Tongs, 73, 74
Trays, 73–74

Variable contrast papers, 80, 83–85

Washing, *see* Film
 paper, 74–75
Wetting agent, 77